CHICAGO
SHAKEDOWN

CHICAGO
SHAKEDOWN

The Ogden Gas Scandal

JOHN F. HOGAN | *Foreword by John S. Maxson*

THE
History
PRESS

Published by The History Press
Charleston, SC
www.historypress.com

Copyright © 2018 by John Hogan
All rights reserved

First published 2018

Manufactured in the United States

ISBN 9781467139519

Library of Congress Control Number: 2018936080

CONTENTS

FOREWORD

In *Chicago Shakedown*, John Hogan focuses on backroom political deal makers during the quarter century between the World's Columbian Exposition of 1893 and America's entry into World War I in 1917, arguably the most fascinating period in Chicago history.

It was during this era that Chicago redefined itself. Starting as a tough railroad, manufacturing and stockyards town, it became one of the world's premier centers for art, music and higher education. While enduring burgeoning growth from a population of about 1.1 million in 1890 to 2.7 million by 1920, Chicagoans planted the seeds for greatness. For example, the University of Chicago (founded in 1890), the Chicago Symphony Orchestra (1891), the Art Institute of Chicago (1893), the Field Museum (1893) and the University of Illinois at Chicago (1896) are a few of the world-class institutions that grew out of this period. The Chicago Sanitary Ship Canal, which reversed the flow of the Chicago River and diverted sewage away from Lake Michigan, was opened in 1900 and is considered to be the Eighth Wonder of the World.

But while Chicagoans were amazing the world on one hand, growing pains on the other included immigrants segmenting the city and establishing a basis for ethnic and racial discrimination. Labor unrest had resulted in the Haymarket Bombing a few years earlier and the Pullman Strike in 1894. In addition, widespread and heavily publicized political corruption had left an indelible stain on Chicago's reputation. Cook County Democratic Party chair Thomas Gahan, political boss Roger

Sullivan, Chicago Mayor John Hopkins, U.S. senator William Lorimer and other elected officials of both parties were at the center of this.

For me, the most interesting of these was Sullivan, who was born in 1861 to Irish Catholic immigrants in a small town in northern Illinois and traveled to Chicago to work in the streetcar barns. He emerged as a political leader and, eventually, as the undisputed boss of the Democratic Party, a status he retained for most of his adult life. He died in 1920 at the age of fifty-nine, leaving a fortune valued today at an estimated $100 million, much of it from brokering deals with his friends in politics and selling shell companies with franchises to do business in the city. Though he owned and operated the Sawyer Biscuit Company, a legitimate business, Sullivan was apparently convinced by the one elected office he held as clerk of the Cook County Probate Court that the benefits of working behind the scenes exceeded having official responsibilities. Even so, he had many, many friends, moved in top social circles and played a key role in many political battles, including the election of President Woodrow Wilson.

During modern times, the indictments and imprisonments of literally hundreds of top political leaders in Illinois make it hard to imagine that the extreme corruption during the early part of the last century went unpunished. Despite a barrage of exposés in the newspapers, there was neither the will nor the way to prosecute abuse of political power, a contrast that underscores the importance of this instructive and insightful book.

John Hogan takes the reader into the center of this backroom deal making and creates a strong appreciation for the challenges Chicago has overcome to endure as one of the great cities of the world.

JOHN S. MAXSON
Retired President and CEO
Greater North Michigan Association
Chicago, Illinois

Maxson's great-great-grandfather Alson Sherman
was the sixth mayor of Chicago, 1844–45

PREFACE

In 2010, when Alex Burkholder and I began work on a book about two of the most devastating fires in Chicago history, both at the former Union Stock Yards, one of our goals was to acquaint new generations of readers with milestones long forgotten but well deserving of recollection. A forgotten fires sequel followed. Then came a book about the bloody Republic Steel Strike of 1937, succeeded by one on the Chicago Beer Riot of 1855, which I coauthored with my wife, Judy E. Brady.

My intent has never been to do a series about forgotten or little-remembered episodes in the city's history, yet here we are at number five. There is something almost genetic about Chicago's political shenanigans that impels writers to keep digging. Thus, buried under decades of subsequent scandals, emerges the Ogden Gas affair and its supporting cast of suspects, usual or not. At the time, one good government proponent branded Ogden Gas the most disgraceful affair to date in a city steeped in such mire. Later schemes may have shoved Ogden into the background but haven't made it any less intriguing, especially since one of the ringleaders was the mayor of Chicago and the governor of Illinois a probable beneficiary.

It was my great good fortune that Judy agreed to don her editor-in-chief hat one more time. As with all the other undertakings, this one would not have reached conclusion without her.

Chicago business leader John Maxson, whose enthusiasm for local history knows few limits, answered the call to pen the foreword, for which I am extremely grateful.

Longtime friend Andrea Swank is another professional editor who never seems to have the good sense to quit while she is ahead. As always, her work has been invaluable.

Carla Owens's skills as an information specialist have left their mark on page after page. Matthew Owens, Carla's spouse, is one of Chicago's busiest and most accomplished artists. I was most fortunate to be able to enlist his talents.

The Chicago Public Library will never be the same now that Lyle Benedict has retired as chief of the Municipal Reference Collection. Who needed a computer when Lyle was available? There is a scene in the Hitchcock movie *Vertigo* where Jimmy Stewart is looking for someone who could tell him "who shot who at the Embarcadero in 1848." If the setting had been Chicago and the site in question, say, the Levee or Sands districts, Barbara Bel Geddes would have directed Jimmy to Lyle Benedict.

Four floors above Municipal Reference, Morag Walsh and her associates at Special Collections were unfailingly helpful and courteous.

Charles Ezaki stepped forward as he's done before to deliver urgently needed help with photo details.

Finally, Ben Gibson, esteemed commissioning editor at The History Press, has now been through all five of these offerings and claimed to be "excited" about working on yet another. If Ben ever decides to leave publishing, he could look forward to a bright career in politics.

J.F.H.
September 2017

INTRODUCTION

Political corruption in Chicago has continued largely unabated since the days when hogs roamed freely and plank sidewalks bordered streets that alternated between choking dust and ankle-deep mud. Historical accounts are filled with tales of bribery, kickbacks, vote buying and all manner of scams aimed at enriching the connected at the expense of the taxpayers. The most significant difference between the miscreants of old and their more contemporary counterparts is that the old-timers got away with their misdeeds. They weren't any smarter or better at avoiding detection. If anything, they were more open, even brazen, and for good reason: few were prosecuted. Local authorities might go through the motions of an investigation, the newspapers would editorialize, good government organizations would demand reform. Then the heat would die down, as it always does, while Chicagoans awaited the next installment. One noteworthy exception occurred when a U.S. senator from Illinois was expelled from that body (but not prosecuted) for benefiting from a corrupt scheme. The supreme irony of it all? There was no evidence that the man had broken the law.

The pattern of actual lawbreakers avoiding prosecution began to change in the 1970s, when the federal government, manifested in the office of the U.S. Attorney for the Northern District of Illinois, began to pay closer attention. More than 1,500 elected officials and government employees were convicted of corruption in the district between 1976 and 2013, according to a study by the University of Illinois–Chicago. During roughly the same

period, 30 aldermen, or nearly one-third of city council members serving at the time, were convicted of a criminal offense, usually involving corruption.

Few, if any, displayed the cunning and audacity of the politicians who engineered a con job that rocked the city in the 1890s. One paper called passage of an ordinance to create a mysterious Ogden Gas Company "the most disgraceful act" in the history of the "disgraceful" Chicago city council. The caper made multimillionaires (in today's dollars) of its perpetrators, who, to inject a cliché, laughed all the way to the bank. What set this infamous affair apart from other schemes was the direct participation of a sitting mayor of the City of Chicago.

Nearly a century after his death in the great influenza epidemic of 1918, John Patrick Hopkins, Chicago's youngest and first Irish Catholic mayor, remains an enigma. A school dropout at thirteen in his native Buffalo, he enjoyed a remarkably successful career in business and politics and died a multimillionaire. Trained as a machinist, he presided over a flourishing mercantile company and made a number of shrewd investments. A nonsmoker and nondrinker, he associated with politicians who elevated drinking and cigar smoking to an art form. Lionized by church hierarchy as a model of Catholic laity, he looked away from open gambling and prostitution and helped engineer the Ogden Gas affair. An ambitious politician who saw his career rising meteorically, he sacrificed it to carry out the Ogden scam. He voluntarily left the mayor's office at thirty-six after serving only fifteen months. Even during a term that brief, he managed to earn millions of dollars—along with the scorn of opponents, who branded him the most corrupt chief executive in Chicago's sixty-year existence.

Handsome and fastidious (the newspapers called him "Dapper Johnny," "urbane" and "Chesterfieldian"), Hopkins didn't seek female companionship, other than that of his mother and three unmarried sisters. Artists' renderings at the time of his mayoralty depict a somewhat portly young man. A newspaper profile described his hair as "glossy black, with a tendency to break out in ringlets; his eyes are brown and kindly. He possessed a fascinating smile which plays under [a] drooping mustache.… [I]n dress he is faultless. His tailor says he is 'finicky.' A 'finicky' man is supposed to be the affect of a 'fussy' woman." He died a bachelor.

Along with business, politics, his social clubs and the women in his family, Hopkins's life included one additional influence of paramount significance—Roger Sullivan, longtime Democratic boss and behind-the-scenes manipulator. Roger C. (for Charles), as he was called, was born in Belvidere, Illinois, some eighty miles northwest of Chicago. Like Hopkins,

who was a few years older, Sullivan worked early in life as a machinist. Together, they fashioned a political machine that remained a force on the local, state and national levels until their deaths a year and a half apart, both at age fifty-nine. Their machine lived on in a line of succession vaguely resembling that of a royal lineage—Sullivan to George Brennan, to Anton Cermak, to Ed Kelly and Pat Nash (Sullivan's next-door neighbor) to Richard J. Daley and the remnants of the Daley machine.

Hopkins and Sullivan became acquainted as aspiring young party workers and stayed joined at the hip, as it were, personally as well as politically, for the next thirty-five years. Political rivals and the press invoked Hopkins-Sullivan as if it were one, long, hyphenated word to describe machine politics at best—or corrupt government at worst.

For all their similarities—in age, religion, employment background—they seemed an oddly matched pair, the fashionable bachelor and the rather drab father of five, a stolid, round-faced man who could have passed for an undertaker. Sullivan, who did enjoy a glass and an unlit cigar, preferred to conduct business from behind the curtain and spoke publicly only when necessary. Hopkins relished the opportunity to don a top hat, carry a rolled-up umbrella and take his place in the front ranks of the Cook County Democratic Marching Club, a group of fun-loving politicos who dressed in formal wear and participated in parades for sport and the libations that followed.

According to a *Chicago Tribune* report, Hopkins once returned from out of town to find his friend waiting for him in his, Hopkins's, bed to make sure the mayor didn't lose his resolve to sign the Ogden Gas ordinance. Years later, Sullivan would stand watch over Hopkins's deathbed. During a lull in the political wars, the pair escaped to Mexico—for six weeks. Men have been known to get away from the womenfolk for a weekend, a week or even two for some hunting, fishing, golf and poker. What Helen Sullivan thought of Roger C.'s and Johnny's lengthy sojourn south of the border is anyone's guess. The Mexico getaway marked the beginning of more extensive Hopkins-Sullivan journeys. In the summer of 1909, Johnny, Roger and a political figure from Kentucky toured Europe from one end to the other—from Paris to Budapest to Spitzbergen. Spitzbergen? "Mr. Hopkins and I always wanted to see it," Roger explained. Four years later, the two expanded their horizons yet again, exploring not only Europe but South America as well.

Was there more to the Hopkins-Sullivan relationship than an ironclad political alliance and unstinting friendship? No direct evidence exists to

suggest so, but one is left to wonder. In particular, Hopkins's lifestyle raises questions about what made the man tick. Handsome, well groomed, well tailored, wealthy, exuding charm, he could have had his pick of eligible women. A Hopkins courtship and wedding would have set the society pages abuzz. Nothing wrong with his choices or whatever his orientation may have been, but the fact remained that the man chose to spend much of his leisure time with his mother, his sisters, his men-only clubs and Roger Sullivan. "He was never a 'rounder' in his life," a newspaper profile stated.

Sullivan, on the other hand, married comparatively young, fathered five children and, from all appearances, enjoyed the love and support of his wife and family until the end of his days. Little doubt exists as to which man owned the dominant personality. Sullivan emerges as an almost Svengali-like figure, utilizing Hopkins's charisma to further their mutual ends. Chicago authors Herman Kogan and Lloyd Wendt, for example, submit that the Ogden Gas deal had its genesis with Sullivan, who sold the scheme to his partner. About a decade after Hopkins left the mayor's office, their roles seemed to reverse, with Sullivan becoming the public face of the tandem while Hopkins devoted most of his time to his personal business affairs.

Hopkins ascended to the mayoral chair after the assassination of Carter Harrison I. He won a special election to fill the remainder of the term by defeating the alderman chosen as interim mayor by the city council. Was it his idea to run? Did Sullivan instigate it? Was it a collegial decision, possibly involving a band of corrupt aldermen known as the Gray Wolves? The gang pulled off its big con near the end of Hopkins's short term. Did he seek office for the express purpose of staging this or some similar plot when the time was ripe? Or did the scheme evolve later? What role did Governor John Peter Altgeld's nephew-in-law, John Lanehart, play? Was he part of the cabal or just a stand-in for the governor? Intriguing questions all. Though given to better turns of phrase, Johnny could have quoted Tammany Hall's George Washington Plunkitt: "I seen my opportunities and I took 'em."

The young mayor got off to a good start. In his inaugural address, he vowed to place the city's shaky finances on a sound business basis. He promised, and later delivered, a nonpartisan civil service board to oversee the selection and promotion of police officers. He created a network of free public bathhouses, presided over annexations of suburban territory that greatly increased the city's size, substantially reduced the number of hazardous grade-level rail crossings and tried gamely but unsuccessfully to mediate the disastrous Pullman Strike of 1894. (Hopkins had been a high-ranking Pullman executive prior to a falling out with George Pullman.)

Hopkins's impressive accomplishments soon became overshadowed by less admirable endeavors. These later actions mocked the closing words of his inaugural remarks: "No further grants [to private corporations] ought to be made that do not provide full compensation to the city for valuable privileges given." With Sullivan, the Gray Wolves and their Republican fellow traveler, Billy Lorimer, Hopkins furthered state legislation to more than double the length of utility franchises, as money flowed freely in exchange for "aye" votes. The schemes masqueraded as benefits to the public, but the true intended beneficiaries were, of course, the insiders.

Mayor Hopkins and his cohorts waited until the final weeks of his term to spring their magnum opus. Seemingly from nowhere, an ordinance granting a fifty-year franchise to a phantom company landed in the city council, and it won approval the same night with practically no discussion. Johnny left town immediately afterward. The press and public smelled a rat, but whose was it? No one behind this Ogden Gas Company was identified. A *Chicago Daily News* cartoon depicted a Mother Chicago figure sternly confronting a Hopkins-like character, who, in turn, is regarding Ogden Gas in the form of an overfed hog, chomping in a municipal garden of greenbacks. Other characters, presumably Gray Wolves, gaze innocently in various directions. "Mother Chicago" is saying, "Now, then, is nobody responsible for this monster?"

The cognoscenti had a pretty good idea as to the identities of some, if not all, who bore responsibility, as well as to the intent of the ordinance. Council members not only had seen but participated in these "sandbag" ploys as well. In the state capital of Springfield, these gambits became known as "fetcher" bills. The game wasn't particularly sophisticated: float a piece of proposed legislation detrimental to some company or interest group, then see how much the initiative would fetch from the target to make it go away. The target in this instance was the Peoples Gas Company and its ally, a consortium known as the gas trust. Unless paid to go away, Ogden Gas, armed with a half-century franchise, could pose an almost limitless competitive threat. The ensuing opera buffa lasted for years, but Johnny, Roger and the gang ultimately split a multimillion-dollar jackpot.

Hopkins never ran for public office again, but he stayed active in party affairs, holding leadership posts at the county, state and national levels. In tandem with Sullivan, he called or attempted to call the shots, seldom an easy task, given the feuds, rivalries and internecine warfare that persisted. Alliances, often crossing party lines if money or the settling of personal grudges were involved, got made, broken and re-formed to suit

the moment. The prime example of such an alliance was the Hopkins-Sullivan entente with William Lorimer, the Republican "Blond Boss," who became the only U.S. senator ever expelled from that body because of an election tainted by bribery. Evidence strongly suggests that Sullivan delivered Democratic votes to help elect Lorimer, even though the two pretended to be political enemies.

For his part, Lorimer always stood ready to produce Republican help when Sullivan needed it. Such mutual back-scratching wasn't unusual among "political entrepreneurs," a term employed by Lorimer biographer Joel Arthur Tarr. "The typical urban political boss or machine politician," Tarr wrote in *A Study in Boss Politics: William Lorimer of Chicago*, "regarded politics as a business and used his power for personal gain. He was a businessman who had as his chief stock in trade the goods of the political world—votes, influence, laws, and government grants—which he utilized to make a private profit." In the twenty-first century, many have bemoaned the lack of bipartisan cooperation in Washington. Those seeking a model of bipartisanship are invited to look back at the Illinois of more than one hundred years earlier. Bipartisanship was prevalent, but its objective was hardly the advancement of the public good.

The cast of characters that inhabited the Hopkins-Sullivan-Lorimer universe represented the stuff of Chicago legend—Mayors "Big Bill" Thompson, the Carter Harrisons I and II; Aldermen "Bathhouse John" Coughlin and Michael "Hinky Dink" Kenna; Governor John Peter Altgeld; traction mogul Charles Tyson Yerkes; utilities magnate Samuel Insull; railcar baron George Pullman and on and on. All streaked across the late nineteenth- and early twentieth-century skies like so many comets, offering spectacle to their contemporaries and fascinating pieces of a puzzle to historians who now attempt to fit them together.

I

BUFFALO, BELVIDERE
AND THE WEST SIDE

Throughout the years, even when he was running for the U.S. Senate, Roger Sullivan volunteered little about his early life. He stated that he was born in Boone County, Illinois, about eighty miles northwest of Chicago, worked on a farm in his youth for eight dollars a month and his father died when he was a boy. One of those statements was patently untrue. Sullivan's father, Eugene, died in 1886 in a mental institution near Monroe, Wisconsin. He was forty-nine. The elder Sullivan was committed after being judged insane, according to a family history. The family records offer no further clue about Eugene's condition, but the term *insane* cast a wider net in the nineteenth century and is now believed to have included such afflictions as Alzheimer's, Parkinson's, catatonia, alcoholism and other ills. At the time of his father's death, Roger Sullivan was twenty-five, newly married and working as a custodian at Cook County Hospital.

When he arrived in Chicago at age eighteen, Sullivan settled on the West Side, home to a growing Irish American community. There he stayed for many years, never straying far, in spite of eight changes of address in little more than a decade. Like Hopkins, he entered the labor force with his hands, as a machinist in the West Side Railway shops at $1.75 a day—not much, but an improvement over $8 a month on the farm. Between 1879 and 1885, the year he married, he shuffled between boardinghouses and briefly attended a business college.

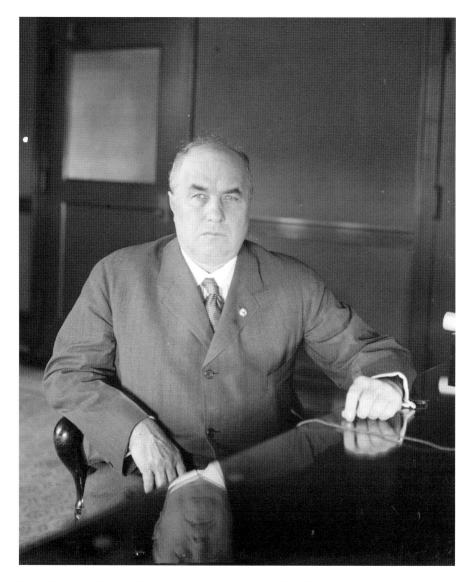

John Hopkins's lifelong friend and political ally, Roger C. Sullivan, was a power in local, state and national politics for three decades. Sullivan supposedly enlisted Hopkins in the Ogden plot. *DN-0063436*, Chicago Daily News *negatives collection, Chicago History Museum.*

Young Roger was already developing a taste for politics, although his first experience might have soured someone less determined. With the 1882 mayoral campaign heating up, a friend working at the behest of the streetcar company asked him to help get out the vote for one of the candidates in the

Republican primary. Roger set aside his Democratic leanings. He not only agreed but did a first-rate job. Then, when the Democratic primary neared, another friend sought his help. Pleased to be back among members of his own party, Sullivan was glad to oblige. When primary day rolled around, the first man who had approached him on behalf of a Republican again sought his help—for Democratic rivals of his other friend.

"You're a Republican!" Roger protested. "This is a Democratic primary!" He failed to grasp that the man, as well as the company, were working both sides of the street.

"That's my business," the man replied.

"Well, I'm sorry," said Roger, who explained that he'd promised to help the other friend. "I have to stick to my word."

The double agent seemed to shrug off the rebuff, and each man went back to work for his respective candidate. The next day, the company political operative informed Roger that he was fired.

"Just for that?" asked an incredulous Sullivan.

"Just for that," he was told.

The lesson he learned was that you don't practice politics against your bread and butter. But he also established a principle that would define his political career: Roger Sullivan never breaks his word.

After he left the car barns for work at County Hospital, Sullivan became active in ward politics and began to develop his leadership skills. A solid, round-faced young man with a bearing that could seem off-putting, he nevertheless projected a warmth and self-assurance that drew others to him. A friend named Billy Legner, later a millionaire like Roger, remembered their first meeting. It occurred at a county convention, the type of gathering where he might have met John Hopkins for the first time.

Legner remembered:

> *I had heard a great deal about this West Side youngster, who, although only in his twenties had become a real leader in [his] ward. In those days, the county conventions were no parlor affairs. Unless the rightful delegation got to the hall first, they would find their political rivals in their allotted section. It was either battle harder than the other crowd or stay out in the cold. Roger and his crowd never stayed out in the cold. I warmed to him as soon as I met him. I found him humorous, friendly and attractively aggressive with a dash of resourcefulness about him that indicated the progress he would make in time.*

Sullivan worked for a short time as a custodian at the old Cook County Hospital while he climbed the political ladder. *Courtesy of Chicago Public Library, Special Collections and Preservation Division.*

Sullivan began to fulfill that prophecy in 1886 when he secured a patronage job in the revenue department at Chicago's federal building. Grover Cleveland had become the first Democratic president since before the Civil War, and loyalists such as Roger were filling openings which had been closed to them for more than a quarter century. He stayed active in county politics, unsuccessfully tried to help elect a friend to the drainage board and, by 1890, felt ready to try for an elected office of his own.

There is no record that Sullivan crossed paths early on with fellow West Sider Billy Lorimer, even though the young men shared much in common and their careers would follow similar trajectories. Lorimer's Scot Presbyterian family emigrated from Manchester, England, and settled in Michigan and then Ohio before moving to Chicago when Billy was ten. His father was a minister whose collection plate was never full enough to help him avoid a succession of physical jobs necessary to support his wife and six children. Perhaps not knowing or caring, the Lorimers located in a neighborhood heavily populated with Irish Catholics. Millions of immigrants, particularly the young, became assimilated, but Billy seemed to take the process a step further. Despite his background, he closely identified with his new neighbors. Many of his childhood friends were of Irish descent,

boys with whom he formed early and enduring bonds cemented in later life by politics and business ventures. They sprang from the same urban soil, his biography notes. He remained tied to the West Side throughout his life. Lorimer married an Irish Catholic, converted to Catholicism and raised all eight of his children in that faith. His politics, nominally at least, stayed Republican, perhaps in deference to his father's memory.

The elder Lorimer died shortly after the family arrived in Chicago. Billy went to work to help support his mother and five younger siblings. He never spent a day in a classroom. His mother taught him the alphabet; a Sunday school teacher tutored him in her home once a week for two years. Like Sullivan, he did whatever he could to earn a dollar—selling papers, shining shoes, hauling coal, driving a carriage, working in the stockyards.

Not long after he started selling newspapers, Lorimer had an unpleasant experience that nonetheless led to a lifelong friendship. Several older boys robbed him of his newspapers. "I raised my voice in lamentation," he remembered years later. Another older boy, a paper peddler like himself, came to his aid. The boy's name was Michael Kenna, better known in adulthood as "Hinky Dink" Kenna, colorful, corrupt and seemingly perpetual Democratic alderman of the notorious First Ward and overlord of the vice-infested Levee District.

"Wait right dere," Kenna ordered as he ran around the corner. Five minutes later he returned with the papers.

"People have wondered why I [as a Republican] do not oppose him when he runs for office…" Lorimer continued. "He came to me not long ago [and] said with his old time brogue, 'I hear you may be a candidate for United States senator. When you are let me know and the member of the legislature from my district will vote for you.' I sent no word to Michael Kenna, but I got the vote he promised." (U.S. senators were elected by members of their state legislatures until 1914.)

Ironically, the paper Lorimer hawked as a boy was the *Chicago Tribune*, which would become his fierce political opponent and run the exposé that would lead to his expulsion from the U.S. Senate.

Just as he was wearying of his debilitating work at the stockyards, Lorimer got a lesson in how to get ahead in Chicago. The uncle of his Sunday school teacher happened to be an alderman and used his clout to get Billy a job as a streetcar conductor. That experience had to leave a lasting impression of the benefits to be gained or bestowed by political patronage.

Lorimer's infatuation with politics crystallized during the 1884 presidential election. He admittedly became obsessed with the candidacy

of James G. Blaine and didn't hesitate to tell anyone who rode his Twelfth Street car that the Republican was "the greatest man in the world." He said, "I talked Blaine to every passenger who would listen to what I said." When Blaine lost, Lorimer said he "took the news as a personal bereavement," but he also did something about it. He gathered about six friends in his mother's kitchen and formed a Republican precinct club. Since Republicans were almost as scarce as Whigs in that end of town, Billy sold his heretofore politically indifferent pals on the prospect of GOP patronage jobs if their work helped elect the party's candidates. From then on, politics became his only calling. He'd become convinced, a *Tribune* retrospective declared, "That his newly chosen field of activity would yield more profits than the grocery business, or the butcher business, or any occupation open to a man of nimble wits but of little education and little capital."

William Lorimer was a rather short, stout man with reddish blond hair and shaggy mustache to match that gave rise to his nickname. With Hopkins, he shared an aversion to tobacco and alcohol, probably another legacy of his father. With Sullivan, he shared a devotion to family and a reputation for always keeping his word. In another Roger parallel, Lorimer didn't talk a lot unless he had to, but he possessed one skill that all politicians consider invaluable: an ability to communicate a genuine liking for people and a concern for their well-being. As a member of a distinct minority himself, he moved easily among the polyglot nationalities that populated the neighborhoods just beyond his own—Germans, Bohemians, Poles and Russian Jews among the most notable. In 1885, Lorimer leveraged his friendships among the Irish and Germans who made up most of his ward into election as Republican ward committeeman. Two years later, he supported the winning candidate for mayor and was rewarded with appointment as an assistant superintendent in the water department.

In 1891, Lorimer backed another victor in a bitter four-way race for mayor. Four years earlier, popular incumbent Democratic mayor Carter Harrison I had decided against seeking a fifth two-year term. Now, he was making a belated comeback attempt against the incumbent Democrat, Mayor DeWitt Cregier, who was supported by Hopkins and Sullivan; the Republican candidate, Hempstead Washburne, backed by Lorimer; and an also-ran. Harrison finished third, as the Democrats split their vote and allowed Washburne to squeak in. The race formed the groundwork for a lifetime of enmity between Hopkins-Sullivan and Harrison's son and political heir, Carter II, who blamed the pair's scheming for his father's defeat.

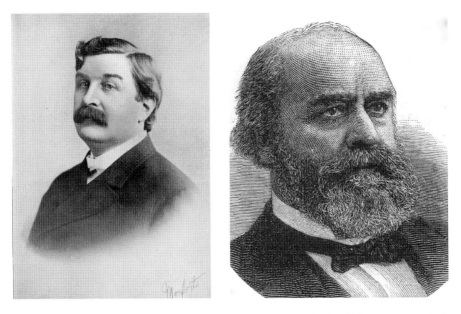

Left: The Republican "Blond Boss," William Lorimer, became the first U.S. senator expelled from that body for participating in a corrupt scheme. Lorimer and Democrat Sullivan sometimes cooperated politically for personal gain. *Courtesy of Chicago Public Library, Special Collections and Preservation Division.*

Right: Mayor Carter Harrison I was assassinated two days before the scheduled closing of the 1893 World's Columbian Exposition. Hopkins succeeded him. *Courtesy of the Chicago Public Library.*

Mayor Washburne elevated Lorimer to superintendent of the patronage-rich water department. On his first day, Billy fired twenty-five Democrats and replaced them with his followers. He continued as the mayor's de facto patronage chief. Silk stocking Republicans and the newspapers that supported them blanched at such raw politics, setting the stage for years of infighting between "machine" Republicans, personified by Billy Lorimer, and their mainline adversaries, backed by the *Tribune*. The old guard would exact its ultimate revenge against the Blond Boss two decades later. But first, Billy had a good, long run ahead of him. He began the first of six terms in the U.S. House in 1895 and continued to serve through 1909, with a two-year hiatus from 1901 to 1903 after an upset defeat. He compiled a competent though unspectacular record, generally voting the Republican Party line while looking out for the interests of the ethnic voters and manufacturing companies that formed the bedrock of his West Side turf.

John Patrick Hopkins, Chicago's twenty-ninth, youngest and first Irish Catholic mayor, sacrificed a promising political career to participate in the Ogden Gas scheme. *Courtesy of Chicago Public Library, Special Collections and Preservation Division.*

When John Patrick Hopkins arrived in Chicago from Buffalo, New York, in December 1880, George M. Pullman's grand social and industrial design was entering its final phase of construction. Pullman had purchased 4,300 acres about fourteen miles south of the city on which to build a railcar manufacturing complex adjacent to a model town to house many of his workers. The plant would include a wheel works, foundry, rolling mills, hydraulic presses, lighting and paint shops, a vast lumber yard and more—everything required to assemble and then send fleets of freight, passenger and sleeping cars zipping across the nation. Eventually, Pullman would marshal an army of more than five thousand workers. The town, owned and operated in total by the company—with no elected officials—would offer what its creator saw as an answer to the ills that plagued most urban centers: alcoholism, disease, filth, overcrowding, vice, child neglect. The town of Pullman would contain none of that—no saloons, gambling dens, houses of prostitution. Instead, Pullman—the man as well as the town—would offer a place of order and cleanliness, comfortable homes, good schools, parks and well-maintained streets.

Hopkins found his way to this "workers' paradise" in March 1881, a month before the official startup of the shops. He became one of the first arrivals. As he told it, he merely walked into the office of the plant superintendent and asked for a job.

> *"What can you do?" the man asked.*
> *"Anything."*
> *"What are you willing to do?"*
> *"Anything."*
> *"Do you mean that?"*
> *"Yes."*
> *"Well, I rather like your determination. I'll try you. You can go down to the yards and shove lumber."*

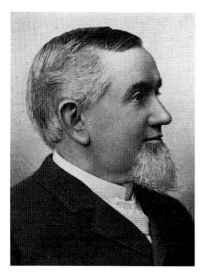

Railcar baron George Pullman elevated a young Hopkins to top positions in his company before the two fell out. As mayor, Hopkins tried to mediate the bloody 1894 Pullman Strike. *Courtesy of the Chicago Public Library.*

Twenty minutes after this brief conversation, Hopkins said he was on the job.

The Pullman lumberyard was a massive, dangerous operation spanning nearly one-quarter of the works' total acreage. It was a place where the company sent Eastern European immigrants—or young Americans willing to do anything. Lumber had begun arriving by rail to be turned into the wooden cars assembled in the erecting shops. The accident rate was high. Falling sections of lumber especially posed a risk. Hopkins not only survived, he prevailed—not that he stayed in the yard that long.

If the superintendent initially thought Hopkins foolish or crazy, he soon changed his opinion. George Pullman and his lieutenants prided themselves on their ability to spot talent as well as potential troublemakers. They detected the first characteristic in Hopkins early on, the second somewhat later. Johnny worked as a laborer in the lumberyard for just five months before he earned his first promotion—to the storekeeping department. Eight months after that, he became the department timekeeper. Another promotion followed after another four months—to company timekeeper, his fourth step up since walking into the plant office less than a year and a half earlier. He completed his climb in 1883, when George Pullman himself appointed him paymaster of the entire works.

During his first two years with the company, Hopkins lived in Pullman housing and quickly learned that in return for living in utopia, the workers agreed to abide by some oppressive rules. The company could send inspectors into a residence at any time and order changes to be made at the tenant's expense. Occupants couldn't purchase one of the homes, vote in elections without being told who to vote for, vote for the people who ran the town, join a union, drink beer, sit on their front stoops in shirtsleeves, use the library without paying dues or attend church in Pullman—unless they worshiped at the Green Stone Church, the only one in town. Like everything else,

the handsome structure was owned by the company, which rented it to the Presbyterians. Employees of other denominations had to travel to adjacent communities to find a house of worship.

These repressive aspects of the Pullman system weren't lost on Hopkins, who empathized with the workers. He himself wasn't that long removed from heating rivets and unloading grain in his native Buffalo or shoving lumber in Pullman. His solidarity was illustrated by British author William Stead, who described how Catholics finally got a church of their own (Holy Rosary), just outside the town boundary at what is now 113th Street and Martin Luther King Drive. To obtain a deed, the archdiocese would have to accept the resignation of the pastor, who had been ministering without a permanent place of worship. The company wanted him gone, according to Stead, "as a punishment for the crime of openly sympathizing with the workingmen," an offense in which he had been fully aided and abetted by John P. Hopkins. "The priest left quietly, over the parishioners' protests and despite their tears, leaving another to finish the church which he had begun." The company also demanded Hopkins's resignation, and he agreed without a murmur. Another man might have lashed out or filed suit for reinstatement, but Johnny already was displaying an appreciation for the politic. He maintained his silence, safe in the knowledge that the company needed him more than he needed the company.

He bided his time, and soon enough, his successor made a mess of things. George Pullman invited Hopkins back without seeking an apology. Hopkins accepted on the condition that he be given a substantial raise. The rail baron figuratively gulped, blinked, then agreed. The episode represented the first time to anyone's knowledge that an employee had gotten the better of George M. Pullman. Equally remarkable was the fact that the employee was in his mid-twenties. He earned a reputation among the rank and file, one of them noted, as the only man in town who dared call his soul his own.

No one ever accused John P. Hopkins of complacency or lack of imagination. In 1885, instead of awaiting a further step up the corporate ladder, he turned his gaze outward. With a partner named Fred Secord, he established a successful general merchandise operation called the Arcade Trading Company. The store, appropriately, was located in the Pullman Arcade Building, "the most expensive and impressive of all the public buildings in town," according to Pullman historian William Adelman. The Arcade was believed to be the first modern indoor shopping mall.

The Arcade Trading Company, under President Secord and Secretary Hopkins, built a loyal following. Hopkins, meanwhile, kept his job with Pullman until his growing activism in the Democratic Party led to an inevitable break with his archconservative Republican employer. With the November 1888 elections on the horizon, the party leadership of Hyde Park Township gave Hopkins a challenging—some would have said impossible—assignment: carry the Town of Pullman for the ticket. He embraced the challenge, fully realizing that one thing George Pullman couldn't abide was political opposition within his kingdom. With that in mind, Johnny left the company on September 17, according to payroll records, and went about engineering a bold move that Pullman would not soon forget.

In the closing days of the campaign, the Democrats rented the Arcade Theatre for a rally and speech by General John McAuley Palmer, a politician who had been around forever and was now the party's candidate for governor. Pullman could have denied the theater space, but perhaps he felt

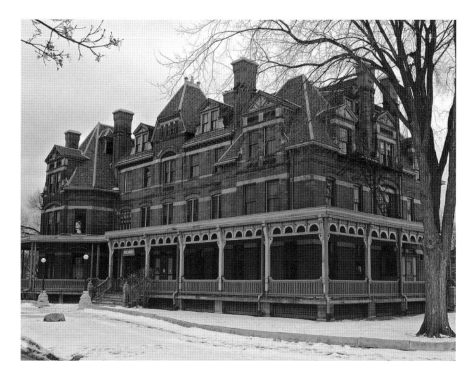

The charming Hotel Florence, looking much as it did when Pullman utilized it to accommodate visiting business associates. The hotel featured the only bar in town, which was strictly off-limits to Pullman workers. *Courtesy of the Chicago Public Library.*

a civic obligation or believed the election was in the bag, so why not let the opposition have a little fun? Outside the Hotel Florence, where an informal reception for Palmer was being held, the real highlight of the occasion took place. Hopkins had recruited Democratic clubs from throughout the south suburbs for a torchlight parade along the streets of Pullman. The faithful turned out en masse. Down streets named for inventors—Watt, Fulton, Stephenson—tramped the boys from the Hegewisch Cleveland and Thurman Club, the Dolton Club and Band, the Oakland Democratic Club and the unofficial stars of the show, members of the John P. Hopkins Fife and Drum Corps. Residents watched from the windows of their row houses. Hardier folk ventured out into the night air. Some had hung decorations from windows and porches. With Palmer and his fellow dignitaries watching from the hotel veranda, "The unwashed and unterrified howled and yelled in the atmosphere which had not often witnessed any demonstration beyond a dance or a literary society," the *Tribune* reported. Pullman had to be glad he didn't live in the town that bore his name.

The torchlight parade and rally marked the prelude to a feat few believed possible: on Election Day, the Democrats handily carried Pullman, although the Republicans prevailed at the state and national levels. Hopkins came to be regarded as a miracle worker. "His stock went up so fast that the political ticker had the jim-jams," the *Tribune* marveled. William Stead agreed. He credited the result to the admiration of the Pullman workers for "the brave fellow" who had stood up to the company. Employees had answered Hopkins's call "in spite of the ever-increasing rumors of official vengeance." By his words, example and magnetic presence, "Hopkins brought manhood and courage to the surface in men who never gave any signs of either before." Rumors of retribution proved true. The company laid off employees suspected of having voted Democrat, attributing its action to lack of work.

With the election out of the way, Hopkins turned his attention back to another cause that he'd embraced—annexation by the City of Chicago of an expanse of suburban townships that dwarfed it on three sides. Chicago, with a population just under 900,000, fell within boundaries that extended only from Lake Michigan on the east, roughly today's Pulaski Avenue on the west, Fullerton Avenue to the north and 39th Street to the south. Pre-1889 Hyde Park Township alone surpassed Chicago in square miles. The townships of Lake, Cicero, Jefferson and Lake View, also large but smaller geographically than Hyde Park, completed the ring around the city.

The majority of all township residents were clamoring for better police and fire protection, cleaner water, better sewage, fewer layers of local

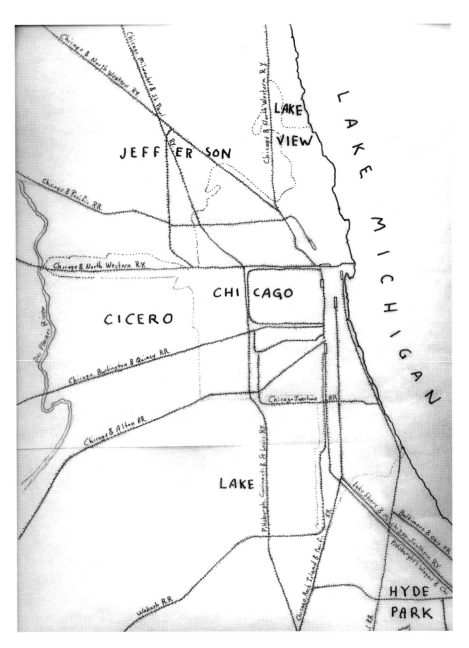

In 1889, Hopkins led a committee that engineered the annexation of five suburban townships by the City of Chicago. The move increased the city's population by more than 239,000. *Courtesy of the Chicago Public Library.*

government and more equitable taxation. Chicago, concurrently, was feeling its expansionist oats, eager to shed its cow town image and play a greater role on the national and international stage. The city relished the prospect of adding a quarter-million new citizens and increasing its square mileage by fourfold. Newspapers were talking up the city as the ideal site for an 1892 World's Fair to commemorate the 400th anniversary of Columbus's landing.

After an initial setback in 1887, suburban annexationists regrouped in 1889 and chose Hopkins as their committee chairman. He repaid their confidence by helping to carry the referendum with healthy majorities in all jurisdictions. After the vote on June 29, 1889, Chicago gained 239,000 in population, bringing its total to 1.1 million; square mileage increased from 131,000 to 174,000; and the number of wards grew from 24 to 34, boosting city council membership to 68. The name John P. Hopkins was becoming known throughout the city. Hopkins capped his annexation triumph by winning election as president of the Cook County Democratic Central Committee.

The other half of Hopkins-Sullivan, meanwhile, was determined to advance his own political career against the odds. Along with Billy Legner and some other friends from the federal building, he helped form a social and political clique they called the Nectar Club. By now, Sullivan and Hopkins had become good friends as well as members of the Democratic County Committee, so the Nectar Club included Johnny and his business partner, Fred Secord. "I had gone into the brewery business," Legner explained, "and was putting out a beer which I named for the fabulous drink of the gods. The club was named for that. There were only eleven of us…but in a small way we made our influence felt in politics."

The year 1890 was shaping up as a bleak one for the Democrats. All signs pointed to a Republican landslide in the fall, yet Sullivan made up his mind to run for clerk of the probate court. Months before the election, he laid out his plans to his pals in the Nectar Club and every other friend he could enlist. They remained skeptical but pledged all-out support. Roger told them, "If you fellows go up and down the city, solemnly telling people that no matter how things look, Roger Sullivan is going to smash the Republican slate and win, and they will believe it, and I will win." Listeners already were growing accustomed to Roger referring to himself in the third person or sometimes in both the first and third, as in, "I, Roger Sullivan…"

Hopkins, too, decided to challenge conventional wisdom and seek a spot on the fall ticket. He chose the patronage-heavy job of sheriff, by Cook County standards a post that demanded few law enforcement credentials but

many political connections. Johnny possessed none of the former but many of the latter. For years, a Cook County sheriff, by law, could not succeed himself. That was all right, went the joke among politicians; if you couldn't get rich in four years, you weren't trying.

When Johnny told Roger how much he'd like to join him on the slate, he got a surprise. Sullivan said he'd already promised his support to Frank Lawler, a South Side congressman a generation older who had grown tired of the Washington grind and was looking for a retirement office closer to home. The miscommunication marked the only time that Hopkins and Sullivan couldn't be found in lockstep on a political matter.

True to his early prediction, Sullivan won his election, the only Democrat on the ballot to do so. Hopkins failed to win the Democratic nomination over Lawler, but he was still young, only thirty-one. Next time would be different.

Three years went by. Carter Harrison I reclaimed the mayor's office in 1891, and Grover Cleveland moved back into the White House after the 1892 election, but the country was sinking deeper into economic depression. Everywhere, corporations and financial institutions were collapsing, and more than four million were left unemployed. At least Chicago could offer some respite to the bleak conditions in the form of the World's Columbian Exposition, the dazzling White City. Symbolized by the outstretched arms of the golden Statue of the Republic, the city welcomed the world beginning on May 1, 1893. President Cleveland officiated at the opening ceremonies. Mayor Harrison graced the platform as well, relishing the start of his fifth term after easily dispatching his opponents less than a month before.

The fair proved an overwhelming success, attracting more than twenty-two million paid admissions. The mayor basked in the reflected glory. On October 28, two days before the scheduled closing, Harrison led a formidable assemblage of public officials from around the country in a Reunion of American Cities, the last major event before the finale. "I intend to live for half a century yet," Harrison boasted to his colleagues. Being engaged to marry a beautiful twenty-five-year-old heiress in a few weeks could have produced such optimism in a sixty-eight-year-old, twice-widowed man.

After the final speech of the reunion was delivered, the mayor returned to his near West Side home, had an early dinner with his son Preston and retired to his study for a nap. While Harrison was sleeping, a man in his mid-twenties knocked on the front door. His name was Eugene Patrick Prendergast, and for some delusional reason, he had been cajoling

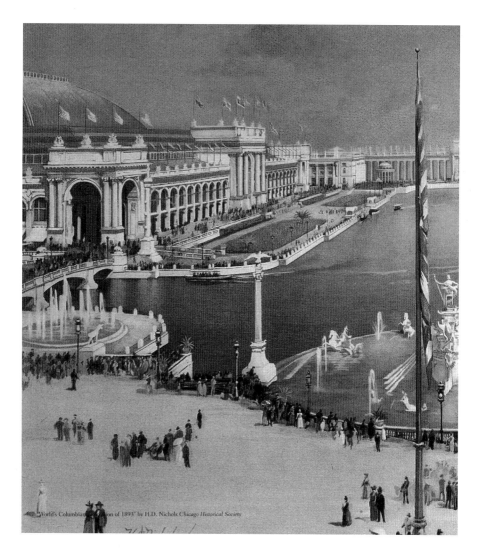

World's Columbian Exposition of 1893" by H.D. Nichols *Chicago Historical Society*

Above and left: The dazzling White City, the World's Columbian Exposition of 1893, attracted twenty-two million visitors as Chicago sought to assert its arrival on the global stage. *Courtesy of the Chicago Public Library.*

Deranged job seeker Eugene Prendergast shoots Mayor Carter Harrison I at the mayor's residence on the near West Side. *Courtesy of the Chicago Public Library.*

Harrison to name him the city's chief attorney, even though he didn't hold a law degree. The maid who answered the door hesitated, then thought she recognized Prendergast, who had, in fact, done some low-level campaign work for the mayor. She asked him to wait while she summoned her boss, but Prendergast followed her. When Harrison opened the study door, his visitor calmly drew a revolver and fired three times at close range. The

mayor collapsed in the doorway, mortally wounded. His attacker fled but surrendered soon afterward at a police station.

Word of the assassination plunged the city into mourning. Between eulogies, aldermen and other city hall figures began plotting. An interim mayor would have to be chosen from the ranks of city council members followed by a special election to fill Harrison's uncompleted term. Nothing changes politics like an unexpected death. No one had to explain that fact to the dapper businessman from the far South Side or his alter ego at probate court.

At the World's Fair grounds, flags stood at half-staff on the twenty-ninth and thirtieth. Memorial services supplanted gala closing festivities, and Beethoven's funeral march became the last music heard. In her book on the Columbian Exposition, *The Fair Women*, Jeanne Madeline Weimann wrote, "This dismal atmosphere underscored the sense of an ending pervading the magnificence of The White City: the dead leaves drifted past the carved facades, already cracking and blurring in the cold lake winds, to pile in neglected corners and float with other debris on the waters of the lagoons."

TWENTY-NINE

The vice president and general manager of the Frazer Axle Grease Company became the interim mayor by vote of the city council, which, under law, was required to choose one of its own. But first, good, gray Republican alderman George Swift, a forty-eight-year-old Cincinnati native, had to survive a plot by the Democratic minority. Gray Wolf alderman John McGillen and his chief backer, Alderman John "Johnny de Pow" Powers, tried to seize the office the Chicago way—by bribing five Republicans a reported $5,000 each to cross over in secret balloting at a special meeting. There being no honor among thieves, two of the five voted for Swift while a third cast a blank ballot. Swift prevailed over McGillen by one vote. History does not reveal whether the McGillen forces got their money back from the double-crossing trio. Before Swift could be declared the winner, Democrats caused the meeting to be adjourned. They grudgingly conceded two days later at a second council meeting. Swift's victory was ratified, again by secret ballot, but not without one final wrinkle. The vote of the sixty-eight-member body came in at 50–19. One alderman apparently voted twice.

Republicans closed ranks behind Swift for the special election set for December 19, 1893. On the evening of November 21, Democratic kingmakers huddled for five hours in the office of County Recorder Sam Chase. Along with Hopkins and Sullivan, the participants included Johnny's business partner, Fred Secord; Roger's boyhood friend Billy Legner; attorney John Lanehart, nephew of Governor Altgeld's wife; and Aldermen Thomas Gahan and John McGillen, fresh from his attempted putsch. Hopkins,

Sullivan, Lanehart and Gahan later formed the nucleus of the Ogden Gas adventure. It's interesting to speculate whether such a scheme was first broached at this early juncture. Johnny had signaled his willingness to run for mayor, but some in the meeting expressed skepticism about his age (thirty-five) and comparative inexperience in government. Everyone came around to Hopkins's side after a state senator told the group that he carried not only Senator Palmer's endorsement but the senator's offer to campaign as well.

The attendees agreed that their first mission would be to placate potential Democratic troublemakers, primarily supporters of the late mayor Harrison. Their efforts failed. An anti-Hopkins bloc formed and lined up behind Frank Wenter, president of the drainage board. Maneuver as his opponents might, Johnny had the momentum. Two days before the party nominating convention, five hundred supporters turned out at the Palmer House for a Hopkins rally. The big guns showed up—Sullivan, of course; his top West Side lieutenant, George Brennan; Lanehart, Gahan and a number of state legislators; and a cross-section of city and county politicians. Even Bathhouse John Coughlin, normally a Harrison man, put in an appearance. The Bath and his First Ward compatriot, Hinky Dink Kenna, were placing their bets on Hopkins this time. At an earlier meeting, Coughlin irked members of the old Harrison coalition by declaring his and Kenna's support for Hopkins. According to Herman Kogan and Lloyd Wendt in *Lusty Bosses of Chicago*, Coughlin said, "This Wenter, he's a nice fella, but he ain't got no public sentiment. Over in our First Ward we want Johnny P. Hopkins, and he's the man we're gonna back."

One by one, the ward bosses rose and pledged their support. Lake View and Hyde Park, where Hopkins had led the annexation cause, offered particularly encouraging words. The *Tribune* was not impressed. The paper lashed out at him as "the dispenser of [President Cleveland's] patronage....He is a rank political boss and nothing more....He is said to be a nice, pleasant young man, but the people of Chicago scarcely will trust a young man of his inexperience, limitations and local political surroundings."

A slim majority of voters disagreed. In the largest turnout ever for a Chicago municipal election, Hopkins squeaked in by 1,200 votes out of 227,000 cast. Republicans alleged widespread fraud but conceded privately that the Democratic-controlled election board could hardly be expected to overturn the results. Two days before Christmas, in the spirit of the season, smiles shone all around at the county clerk's office when Johnny stopped by to pick up his certificate of election. The clerk said good-naturedly, "I'd rather hand the certificate to George Swift."

"I know that," Hopkins replied with one of his famous smiles. "But the fact will make no difference in our friendly relations. Come over and see me at the mayor's office next Wednesday."

About that time, Billy Lorimer and John M. Smyth, furniture merchant and prominent Republican, dropped in to express their regards and exchange pleasantries. Lorimer had played this election straight and took credit for sharply reducing the twenty-thousand-vote plurality of the late mayor Harrison only eight months earlier. Then Johnny left to pay a courtesy call on Mayor Swift. The two agreed that Hopkins would be sworn in at Wednesday's city council meeting.

The inaugural address of Chicago's twenty-ninth mayor, weighing in at a scant one thousand words, stood as a model of brevity and commitment. The new mayor pledged "resolute purpose" to tackle a host of challenges made more difficult by the economic depression. He insisted that the city's finances "be placed in absolute order," that the accounts of the comptroller's office be made as clear and simple "as those of any great corporation" and sought to "gain favorable balances, not increase embarrassing deficits." Hopkins promised to continue to reduce the number of railroad grade crossings, which he blamed for "the murder and menace of life and limb." He reserved his toughest language for the police department, vowing to eliminate appointments, promotions and discharges "dependent upon party service." He assured one and all that "incompetents, drunkards and men… [who] trespass wantonly upon the rights of citizens…must be dismissed from [the] force." Nearing the end of his remarks, he uttered the words that would return to mock him. "Grants hitherto made by the common [city] council to private corporations have almost invariably proven of great value to the fortunate recipients.…No further grants ought to be made that do not provide full compensation to the city for valuable privileges given."

The metropolis of 1.2 million whose leadership Hopkins assumed presented two faces to the world: one, the proud, young recent host of the Columbian Exposition, asserting its arrival among the great cities; the other, a place of squalid neighborhoods, wide-open vice and transparent political corruption.

Electrification was transforming society. Chicago Edison could barely keep up with demand. Streetcars and elevated railways were displacing horse-drawn vehicles. Augmenting downtown service, an elevated line had been built to Jackson Park to carry passengers bound for the fair. Visitors to the White City came away awed by conveniences many had never seen, such as flatirons, heating pads, water heaters and electric coffee pots. They

Beyond the glitter of the World's Fair and a burgeoning downtown lay a city of squalid neighborhoods. *Courtesy of the Chicago Public Library.*

could head for State Street and buy these and other items at emporiums that showcased their wares in plate-glass windows. New construction, such as the world's first steel-framed skyscraper, the Home Insurance Building, was rearranging the skyline. The city announced itself as an educational and cultural hub. No longer merely a home to stockyards and railroads, the metropolis on the prairie could point to the addition of the University of Chicago, the Art Institute of Chicago and the Chicago Symphony Orchestra.

On the day of Mayor Harrison's assassination, an unusually perceptive British writer, editor and evangelist named William Stead arrived in town. Soon after he stepped off the train, he began to record his impressions of Chicago. Taken as he was with the architecture, vibrancy and new cultural amenities, Stead found himself drawn to the underside. The product of his observations became a remarkable book bearing the striking title *If Christ Came to Chicago*, what Jesus would have to say about the place as Stead saw it. The Good Lord, the visitor strongly believed, would not be pleased.

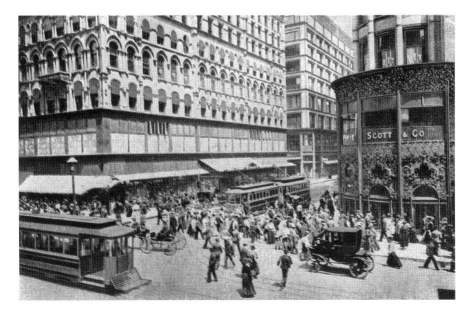

Electric streetcars along with the "L" displaced horse-drawn vehicles at a rapid pace. *Courtesy of the Chicago Public Library, Special Collections and Preservation Division.*

When published in 1894, the book created a sensation. Up front, for example, it displayed a map showing the locations of the saloons, brothels, gambling places and pawn shops that dotted the notorious Levee District of Kenna's and Coughlin's First Ward. Stead wrote sympathetically about the prostitutes, regarding them in general as women who gravitated to that life because of low wages and poor living conditions. But he came down harshly on crooked cops and the alliances among gamblers, politicians and saloonkeepers. He reserved his sternest denunciations for those he called "the swine of our civilization"—chiseling aldermen.

The gentleman from England was nothing if not a quick study. He soon determined that the council constituted a marketplace of corruption where, he estimated, the minimum number of crooked aldermen totaled fifty, leaving only eighteen honest members. Council members were paid $156 a year, so it became logical, Stead concluded, that they—especially those with no other employment—would turn to "boodling," or bribe taking. "It would have been cheaper for the city of Chicago to have paid every one of her aldermen $10,000 a year," he wrote, "if by such payment the city could have secured honest servants, than to have turned a pack of hungry aldermen loose…to fill their pockets by bartering away the property of the city." Stead

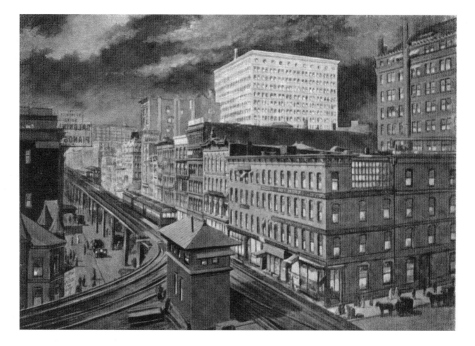

Above: The original elevated line that carried visitors to the World's Fair was powered by steam locomotives, but electricity soon became the power source for the L. *Courtesy of the Chicago Public Library, Special Collections and Preservation Division.*

IF CHRIST CAME TO CHICAGO!

A Plea for the Union of All Who Love in the Service of All Who Suffer

"Said Christ our Lord, I will go and see
How the men, My brethren, believe in Me."
—*Lowell.*

BY
WILLIAM T. STEAD

COPYRIGHT, 1894, BY WM. T. STEAD
(ALL RIGHTS RESERVED)

CHICAGO
LAIRD & LEE, PUBLISHERS
1894

Left: The 1894 book by Englishman William Stead, *If Christ Came to Chicago*, created a sensation with its spotlight on gambling, vice and political corruption. *Courtesy of the Chicago Public Library.*

pegged the annual total of boodle at $5 million, far less than the value of the public's goods and services surrendered to the bribe givers. Payoffs ranged from $300 to $5,000, he stated, with the usual rate falling between $750 and $1,500. A 25 percent surcharge applied to votes necessary to override a mayoral veto. Stead identified two groups of boodlers: a big ring of forty and a small ring of ten. He didn't mention Johnny de Pow by name but did say the big boss "usually can be found in the neighborhood of Powers and O'Brien's saloon on the West Side." He didn't indicate the identity of the little boss. "The secrets of a papal conclave," Stead marveled, "are not more secretly preserved than the details of the conferences between the chiefs… and the corporations who are in for the deal."

Stead lavished praise on Chicago's young new mayor, calling him "Bismarckian"; comparing him to Cecil Rhodes, prime minister of South Africa; and suggesting that the White House might not exceed his reach. The Englishman was writing about the pre–Ogden Gas Hopkins, an official who was building an admirable early record. The mayor cut his salary by 10 percent, surrounded himself with first-rate advisors and set an ambitious agenda for his fifteen-month term.

After ten days in office, Hopkins sat for an hour-long, wide-ranging interview with a reporter. A reader of the piece can't help but conclude that a relaxed, smiling Johnny was having a bit of fun with the unidentified newsman as the mayor leaned back in his chair in a private dining room at one of his clubs. How else to accept the assertion that he'd been "an unsophisticated neophyte" prior to taking office? "He has discovered," the reporter wrote, "that the official politician is up to more ways that are dark and tricks that are vain than he ever imagined." Could this be the "rank, partisan political boss" the interviewer's own paper had railed against not long before? Regardless, Hopkins went on to repeat his promises to force the railroads to eliminate grade crossings, shape up the police department, purge the city workforce of underachievers and whip municipal finances into line. Since settling in, he claimed, he'd been getting only five hours' sleep a night and having many of his waking hours taken up by the pleadings of favor-seekers.

I will not venture on the ancient joke that having teeth pulled is pleasanter than listening to the petitions of office-seekers....One of these fellows sent me seven different delegations in one day to beg the office of street inspector. I asked [the applicant] *why he wanted* [the job]. *He replied unwittingly, "I don't care where you place me* [just] *so I am on the payroll." He would not get the job if there were fifty delegations to back him.*

It would seem that an effective gatekeeper could have held such pests at bay, but perhaps Hopkins's personal style or the practice of the times called for an accommodating approach.

The mayor also referred to underperformers trying to keep their jobs. "Half [the sponsors] who have called on me have asked that Tom, Dick or Harry be kept because he is a good fellow, or is loyal or he is a charming fellow and has a large family dependent on him....I notice that efficiency or diligence is never urged." Hopkins admitted that even his business partner, Fred Secord, tried his patience during the campaign when he urged a contribution of $1,500 to a so-called merchants' association offering its help.

> *I arranged to see them without their seeing me. They were old acquaintances. They tried to work this same racket with me when I ran county campaigns....I told Secord he had better go back to Pullman and attend to the business there. He felt hurt. I believe he thinks to this day that if I had given up $1,500 to those "skates"...my majority would have been 10,000....Fred was never intended for political life. But he is a charming fellow and a first-class partner.*

"Have you given the smoke nuisance any attention?" the reporter asked.

"Only the smoke nuisance in the corridors of City Hall. I don't see where the fellows got all the bad cigars."

The performance was vintage Hopkins, smiling, engaging, witty—the sort of approach that apparently won over a shrewd observer such as William Stead. The man who quickly grasped the workings of the Levee District and city council saw in the mayor a champion of reform. Hopkins's early skirmishes with aldermen provided ample reason for optimism. The mayor's first clash pitted him against traction (a carryover term from the cable cars) king Charles Tyson Yerkes, a prototype robber baron who had come to Chicago from Philadelphia after serving a prison term for financial misdeeds. In the mid-1880s, Yerkes began amassing streetcar lines like so many Monopoly cards, freely bribing aldermen for the franchise rights. Now, at the outset of the Hopkins administration, he wanted to incorporate a western elevated line into his downtown operations. He offered a pittance to the city for the rights, even though the line showed a reported annual profit of $1.4 million. He offered the aldermen a reported $1,000 a vote. The measure sailed through the council but met with a veto from Hopkins, who demanded that the city receive a percentage of the $5.2 million total gross receipts. The ordinance got amended to that end and gained final approval.

It's not possible to gauge whether the mayor sincerely believed in his action or whether he'd begun burnishing his good government credentials to help offset his later moves.

Hopkins was presented with a similar challenge when the council took up an ordinance granting a franchise to a mysterious Metropolitan Gas Company. The minority of honest council members hollered that this was yet another phantom corporation whose sole purpose was to use the threat of competition to shake down the seven companies that comprised the gas trust. Bathhouse John Coughlin had caused the measure to be introduced by his fellow Gray Wolf, Little Mike Ryan. When a straight-arrow alderman demanded to know who stood behind the ordinance, the Bath replied, "This is a good ordinance. We'll name the promoters when the time comes." According to news accounts, the backers had established a $175,000 slush fund to be dispensed equally among the forty members of the big ring and their ten little

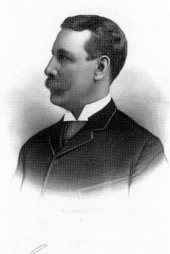

Charles Yerkes's monopolistic control of the city's streetcar lines met with challenges from Mayor Carter Harrison II. Harrison ultimately prevailed, and Yerkes left town for good. *Courtesy of the Chicago Public Library, Special Collections and Preservation Division.*

brothers at a rate of $2,000 per alderman. The remaining $75,000 was to be used to buy the cooperation of other city officials as necessary. Metropolitan Gas won approval, 50–10, but Hopkins torpedoed it with a particularly strong veto message. Supposedly deterred by an onslaught of negative press, some of the boodlers got cold feet. The override vote failed, 42–22, or four short of the required two-thirds majority.

The following week, a determined Alderman Ryan came back with still another sandbag ordinance, this one on behalf of a Hyde Park Mutual Fuel Company. Hopkins threatened another veto. In *Lusty Chicago Bosses*, Kogan and Wendt maintain that the reason was fear of political retribution. Huddling with rambunctious aldermen, the mayor wondered, "How can we win the spring election? Every Democrat is backing this ordinance. If it stands, we don't have a chance." The aldermen didn't heed his warning,

so the mayor fired off a blistering new veto message. Before the inevitable override attempt, Hopkins held a sit-down with Bathhouse John. As the Coughlin biographers relate, Hopkins reminded the alderman that Billy Skakel had been boasting around town that he was ready to blast Bathhouse John out of politics. The fight was likely to be hard, the mayor cautioned, accompanied by the copious flow of both money and blood. Bathhouse John might need the help of a friendly administration. The alderman gave the matter some thought then decided he could have it both ways. He voted to override the Hopkins veto and thus saved face with his cohorts, but he did nothing to win over some likeminded but wavering fence-sitters. The override attempt fell short by four votes.

Mayor Hopkins launched one more good government initiative that cheered Stead but annoyed Coughlin, who, according to Kogan and Wendt, "was beginning to dabble in this kind of racket." The racket, which Hopkins squelched, didn't require any degree of finesse but did reflect Chicago's unofficial motto, "Where's Mine?" Tax collectors were "able to pocket scores of thousands of dollars which ought to belong to the public," in Stead's words, in return for reducing assessed property valuations. The result left the city's total evaluation lower than it had stood twenty years earlier, when Chicago numbered one million fewer residents.

Stead essentially gave Hopkins a pass on two issues: gambling and police reform. He noted that taking the police out of politics represented one of the stands that had helped the mayor win election, but the Englishman conceded that the extraction "is very much like taking a man out of his skin." He admitted that the mayor didn't seem to be trying very hard. One of Hopkins's first acts was to fire an inspector whom Mayor Swift supposedly had tapped to be the next chief and to demote a captain who was a well-known Swift supporter. The captain wrote a letter to Hopkins, complaining that his only offense was to exercise "my right as an American citizen…in voting for the choice of my party, and in my humble opinion, the best man for the position." Apparently, the mayor remained unmoved. Stead sought the opinion of a longtime political observer, who explained that the Democrats believe the police can be divorced from politics while the Republicans do not. Therefore, the way to remove politics from the force is to purge it of those who don't believe it can be done—in other words, Republicans—and replace them with true believers—Democrats.

Stead appreciated the tongue-in-cheek humor, but no one found anything amusing in the way Hopkins employed the police on aldermanic Election Day in April 1894. The stage became set when ward heeler Billy Skakel made

good on his promise to run against Bathhouse John Coughlin for First Ward alderman. Coughlin, figuring Hopkins owed him for his passivity during the Hyde Park Fuel battle, rushed to the mayor's office to plead for help. Johnny obliged. He summoned Skakel, told him he was hurting the party and asked him to get out of the race. Skakel's reply, according to Kogan and Wendt, was, "Nothin' doin'. I'm the next boss in the First Ward an' you might as well know it now."

After Coughlin failed to get Skakel removed from the ballot because of a minor gambling conviction, the Bath's partner, Hinky Dink Kenna, went to work importing street denizens from throughout the city. Into the First Ward they rolled, lured by the promise of fifty cents a vote and all the pub grub they could swallow. *Lusty Bosses* describes, "Cheap hotels, flop joints, deserted buildings, brothels, saloons, empty warehouses, even railroad freight stations—these were the forts where Hinky Dink marshaled the Coughlin voting forces.…When registration day was over, the First Ward had 8,397 voters on the books—almost twice the number that had balloted in the previous mayoral election."

Hopkins made a final plea to Skakel to drop out of the running. Again, the candidate vehemently refused. "There might be a lot of trouble tomorrow, Billy," the mayor warned, adding duplicitously, "and I might not be responsible."

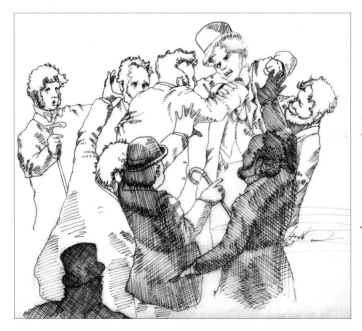

Left and next two pages: Election Day violence in Chicago "occurred with the predictability and regularity of snow in January." The 1894 aldermanic elections, rendered generically here, were among the bloodiest. *Courtesy of Matthew Owens.*

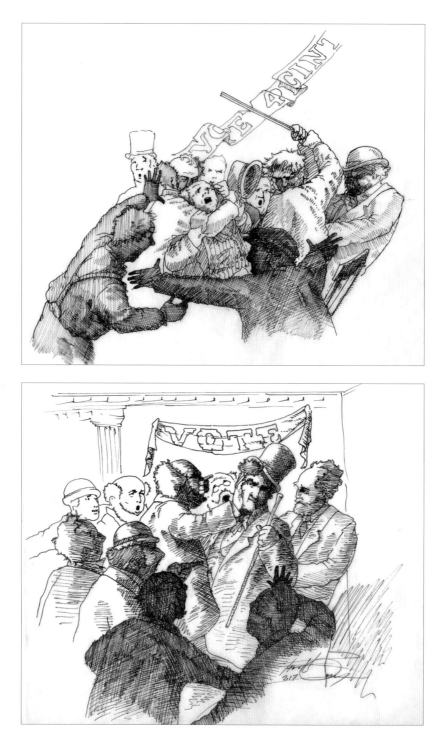

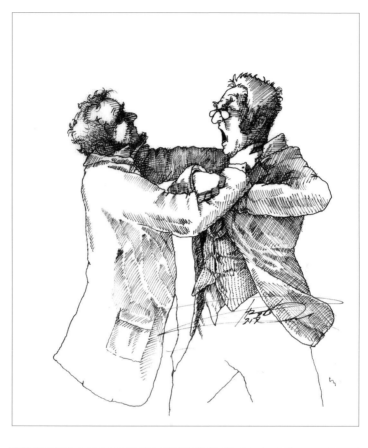

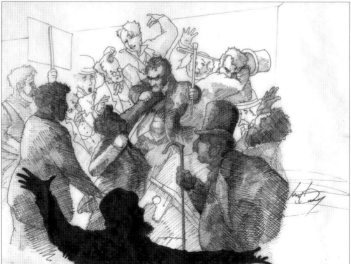

Shortly afterward, Hopkins conferred with the captain of the First District police, and the message went down through the ranks: the big guy who takes care of us over there in the First Ward needs our help on Election Day. And he got it. In the days before the voting, police conducted a campaign of harassment of Skakel supporters, indiscriminately arresting people wearing his campaign buttons, busting up gambling dens operated by his backers and strictly enforcing closing times at saloons displaying his signs. On Election Day, cops looked the other way as roving gangs of Kenna-Coughlin sluggers waged war against anyone who looked like a member of the opposition. The Skakel forces fought back. Throughout the day, shootings, beatings, brawls and rioting swept the ward. When the police did intervene, it was to throw the Skakel men in jail. The newspapers tallied forty Skakel adherents wounded, two critically, with hundreds occupying cells. The Coughlin brawlers escaped with only six serious injuries and no one in custody, winning not only the battles but also the war. The Bath won reelection by better than two-to-one over the second-place finisher. Billy Skakel ran third. But Coughlin's victory proved pyrrhic for the Democrats. A dozen incumbent aldermen who ignored Hopkins's words of caution about pushing sandbag gas ordinances met defeat. With Billy Lorimer orchestrating the Republicans, they captured twenty-two new seats. Election Day violence in Chicago had long occurred with the predictability and regularity of snow in January, but most agreed that the 1894 Battle of the First Ward took the prize. Though he stood accused by the press and good government types, Mayor Hopkins stoutly denied that he had ordered the notorious conduct of the police.

Hopkins, both Harrisons and many other political leaders disagreed on multiple points but shared one basic belief: that gambling appeals to an element of human nature that can be controlled but hardly eradicated by government dictate. Even a moralist such as William Stead wrote matter-of-factly about what he found in the days before Hopkins's election. "The gaming houses were crowded every night, and at the dinner hour, by the dinner pail brigade, just as they always had been; and the gambling syndicate collected their share of the gaming receipts, and, it is hoped, handed over the due proportion to their heirs and representatives of those who had arranged the deal." Stead mentioned that gambling never came up for discussion in the Swift-Hopkins mayoral race. "The Republicans were too busy discussing the city's financial situation and the infamy of the Queen of the Sandwich [Hawaiian] Islands. The Democrats laid low and said nothing for reasons of their own." The

newly formed Civic Federation, however, was shocked, shocked to see that "[g]ambling is going on with the doors wide open and cappers and stool pigeons [hustlers] are plying their vocations to catch the unwary, while the heads of the police department are giving these places ample protection from arrest." The cost of protection, the Civic Federation estimated, ranged from $9,000 to $30,000 a month, paid to municipal, county and state officials. At various times, both Carter Harrison I and Hopkins stood accused of being recipients. The civic group demanded action, as did a number of delegations led by ministers who visited Mayor Hopkins. Unable to run or hide, Johnny tried to calm the situation. Let's be reasonable, he pleaded. Not everyone opposes gambling. Many businessmen want gambling to continue because their customers enjoy it. His blandishments did not placate his callers, so the mayor found it necessary to take action—of a sort. What followed amounted to a variation of the burlesque he'd played with the interviewer to whom he'd confessed his "naiveté of all things political." He needed to satisfy the ministers and the Civic Federation while retaining the allegiance of Kenna, Coughlin and like politicians with a hand in gambling. Police Chief Michael Brennan was summoned. The following day, Brennan issued orders to his men to close every gambling place in the city, and by the weekend, not a die got cast or a card turned in any of them. On Monday, a reporter caught up with the mayor and inquired about the shutdown.

"Who told you the gambling houses had been closed?" Hopkins asked in all innocence. When informed that the word came from Chief Brennan's office, Johnny responded with a classic Hopkinsism. "Well, I don't know about any order on the subject. But I do not issue instructions to any department chiefs. I presume Chief Brennan can tell you all that is to be told about closing the gambling houses." Instead of stopping there, the mayor chose to stretch credulity a bit further.

I think it not improbable that the closing is entirely voluntary on the part of the gamblers. I understand they have been complaining about the hard times. Then within the past two weeks two of these gambling houses have been robbed. I am informed that Chief Brennan is talking of reducing the police force. In view of these things, it is possible that the gamblers fear they will not have adequate police protection hereafter and have concluded to go out of business.

Wait a minute, police protection for gambling houses?

"That is only a suggestion," Hopkins concluded, "which I offer for what it is worth."

Mike Brennan, nothing if not a blunt-spoken street cop, obviously hadn't been coached in Hopkins-speak when asked whether the mayor's order applied to all gambling houses.

"All gambling houses."
"For good?"
"For good."
"All forms of gambling?"
"All forms of gambling—gambling houses, crap games, pool rooms."
"They will not be allowed to reopen under certain promises, then?"
"They will not. The pool rooms of the city were closed on my orders after I had conferred with the mayor on the matter. They will remain closed if it takes the entire police force to do it."

Initially, the gamblers didn't worry; they'd seen pseudo-crackdowns before and understood that conditions would return to normal as soon as the heat subsided. Mayor Hopkins continued to play the game both ways, stating that if anyone could produce his order to close the gambling dens he would buy him a new suit of clothes. His offer reeked of disingenuousness; he had issued no such written order to Brennan. Apparently, the chief's word counted for nothing.

Johnny bobbed and weaved like a champion boxer, and no one—Brennan, the gamblers, the press, the Civic Federation—seemed to understand his strategy. This crackdown was lasting longer than its predecessors, and the gamblers became concerned that the mayor might be serious. Then, more than a month after the shutdown, rumors surfaced that the ban was about to be lifted. Nothing happened. Stories appeared in the papers that the mayor was ready to give in. Several gaming houses whose operators presumably believed what they read reopened but were immediately closed by the police. Brennan insisted that there had been no change in his standing orders. The following day, with no public statement from the mayor, the shutdown ended. Hopkins's last comment conceded that he might not be able to stop gambling entirely, but he would keep the establishments from running wide open. That statement, too, proved misleading. Every gambling place in the city ran full blast with no attempt at secrecy. The mayor's explanation came in the form of an anecdote:

Day before yesterday, I was going to lunch with a friend when we passed under [a construction canopy] *on LaSalle Street, in front of the stock exchange building. When we reached the center…we encountered a big crowd. Peeping over* [the heads]…*I saw a man with a…cloth spread out and a dozen or more men were placing their money on the turn of the dice. I did not wish to create a disturbance of so quiet a game and* [went to find] *a policeman…to arrest the fellow. Afterwards, I wished I had used my authority as head of the police force to make the arrest myself* [because] *no policeman could be found. I went back myself, but before I got there the fellow had flown.*

Hopkins informed Chief Brennan of what he had found and was told that gamblers always use a lookout to warn of an approaching officer. The incident represented a self-fulfilling prophecy. It proved, the mayor said, that gambling could not be stopped, even though,

I am trying to the best of my ability. Chief Brennan had his orders…and he has had no modification of the orders.…There is bound to be gambling, and it is surprising how many reputable businessmen want it to continue. I have had representatives of prominent wholesale houses tell me that they have great difficulty in entertaining their country customers because they cannot take them around to gambling houses.

Stead found it incredible "that the mayor and chief of police were totally ignorant that everything was going on just as before." The Englishman paid a left-handed compliment to the late Mayor Harrison, whom, he said, "At least was bluff, cynical but straightforward in the matter; he openly avowed that he was permitting gambling to go on.…[H]e did not pretend to be doing one thing when in reality he was doing the other. He did not, of course, admit that he was subsidized by the gamblers."

Ever the friend of gambling interests, as well as the recipient of their envelopes, Bathhouse John Coughlin sought one more favor from his friend Mayor Hopkins. The city council had passed an ordinance to extend Homan Avenue and effectively slice Garfield Park racetrack in two. Bathhouse John asked the mayor to issue a permit to keep the West Side track open, despite the fact that it was operated, according to one honest alderman, "by an infamous and disreputable gang." Hopkins also heard from the press and community civic and religious leaders who railed against the evils of the track. The owner of the property, wealthy,

influential Democrat Lambert Tree, got Johnny off the hook. While he netted $58,000 in rent for each race meeting, Tree sent word from a European vacation that he'd just as soon see the place closed. That was enough for Hopkins. He declined to sign the permit, and the street extension went through.

3

CITY ON FIRE

John Hopkins and George Pullman presented a most unlikely pair of luncheon companions on May 9, 1894, at the prestigious Chicago Club. For one thing, Hopkins was suing Pullman for breach of contract over Secord and Hopkins's loss of its retail space at the Arcade Building. For another, the City of Chicago and Town of Pullman had been embroiled in contentious renegotiations of rates for water supplied by the city to the town. Finally, in what some saw as pettiness on Hopkins's part, the city had unsuccessfully tried to get the name of the town post office changed from Pullman to Chicago. One newspaper accused the mayor of pursuing "a vendetta."

It's not clear whether the get-together came about by prearrangement or chance or how much time the two spent together. Hopkins said Pullman told him that he was meeting a delegation of his workers later in the day to discuss grievances that had the employees on the brink of a strike. "[I]t was the first time my attention was called to the troubles," the mayor maintained later. "I was not at all familiar with them. I did not know they were even dreaming of a strike at Pullman."

Not familiar? Trouble had been brewing for at least six months. Most significantly, the company had cut wages five times during that stretch while refusing to lower rents for the housing it provided to employees. Second, as mayor, Hopkins had at his disposal official and unofficial intelligence networks that could have, should have and maybe did inform him of serious labor troubles at a major employer. Third, the mayor continued to operate a

thriving retail business in the adjacent community. Perhaps customers might have mentioned something? Finally, only six years had gone by since he himself worked for Pullman and championed employee welfare. Didn't any of his old friends at the company keep him informed?

George Pullman's meeting with the employees went well enough. He delivered a convincing presentation, explaining how badly the company's sales were being affected by the sour economy and how it was doing everything possible to keep the maximum number of workers on the job at wages it could afford to pay. The delegation left the corporate offices willing to give the company the benefit of the doubt. Then came the thunderbolt. As the grievance committee discussed its next moves, word arrived that three members of the delegation that met with Pullman had been laid off. By a lopsided vote, the grievance committee suddenly became the strike committee.

Long before the Pullman workers walked out of the factory gates on May 11, they found themselves looking at an unwinnable struggle. The more astute among them surely recognized the weakness of their position, but as one worker put it, "We struck because we were without hope." The issues transcended wage cuts and rents. Workers received regular verbal—and sometimes physical—abuse from foremen who manipulated the assignment of piece work to minimize wages. Often, the supervisors simply proved incompetent. Complaints of shop abuses to higher management went nowhere.

The company found itself in excellent shape to withstand a strike, perhaps viewing the walkout as a healthful shock. Not having to meet a semimonthly payroll during a national depression wasn't the worst of fates. All told, the company estimated that it could hold out indefinitely, unlike the strikers, who had scant savings and would immediately miss their already reduced paychecks.

Recognizing their vulnerability, the strikers established a relief committee. Most Pullman families had been enduring hunger and even the threat of starvation, at least since the wage cuts began. With conditions all but guaranteed to get worse, some nonetheless held back from seeking help. "The people are largely Americans who have been used to earning and enjoying the comforts of life," said a newspaper story, "and they are proud....[M]any of them are enduring pangs of hunger rather than let their condition be known."

Less than a week into the strike, Mayor Hopkins came to the aid of his neighbors. His company, Secord and Hopkins, contributed $100 in cash and

$1,500 worth of groceries to the committee. The provisions included one and a half tons of flour and a ton of fresh meat. Secord and Hopkins also gave the strikers the use of seven rooms above its store for use as office space.

The mayor's next contribution came in the form of symbolism. In late May, the strikers held a fundraising dance in the ballroom above the Market Hall. (The company didn't let a little thing like a strike stand in the way of collecting twenty-dollar rent.) Strikers, accompanied by their spouses, friends and other sympathizers, packed the place. Attendance was estimated at one thousand. Another thousand bought the one-dollar admission tickets but didn't attend. All were delighted by the surprise appearance of His Honor the Mayor. To make sure that the newspaper reporters present didn't miss his signal, Hopkins danced with Jennie Curtis, the feisty twenty-three-year-old president of the women's branch of the American Railway Union (ARU). Johnny didn't stay long—he'd made his point—but "the dance was kept up until the early milk trains on the Illinois Central swept past the [Pullman] station," the *Chicago Inter-Ocean* reported.

Shortly after he returned to city hall, Hopkins issued a proclamation—unanimously approved by the city council—calling on Chicagoans to contribute money, food and clothing to the strike fund. A generous response lifted the spirits of the strikers, who days earlier had formed long lines to grab what they could from their nearly depleted storeroom. A resolution thanking the mayor for his generosity became one of the first orders of business at the ARU's national convention, which—by pure coincidence—was being held in Chicago.

On a much more significant note, the union delegates voted overwhelmingly to impose a national boycott of Pullman cars. (The company retained ownership of its sleepers and diners used by the railroads.) The boycott began on May 26, and Chicago remained mostly quiet for more than a week. That was more than could be said for Blue Island, a suburb and major rail junction abutting the city on the southwest. Mobs derailed two trains, beat up one of the engineers and set boxcars on fire. When Sheriff James Gilbert suggested to Mayor Hopkins that they issue a joint appeal to the governor to activate the militia, the mayor replied, "Chicago can handle its own troubles." Conditions in Blue Island, meanwhile, grew worse. On July 2, when Marshal J.W. Arnold and a squad of special deputies arrived to enforce a federal court injunction against the boycott, they were met by swarms of people who told the lawman what he could do with his piece of paper. Arnold sent a telegram to Washington, stating, "I have read the order of the court to the rioters...and they simply hoot at it....We have

had a desperate time with them all day, and my forces are inadequate." He requested the assistance of the army's 15th Infantry Regiment, based at Fort Sheridan, north of Chicago. President Cleveland issued the order.

The following day, Mayor Hopkins received a visit from Pullman Company executive George Brown. The Fourth of July being a national holiday, Brown noted, people throughout the city would have time on their hands, and some might take the opportunity to cause trouble, perhaps targeting his company. He asked the mayor for extra police protection. Hopkins demurred and suggested that maybe the best way to avert trouble would be to settle the strike. That remark ended the conversation. The company couldn't deal with men who were not law-abiding citizens, Brown asserted, a preposterous observation since none of the Pullman strikers had broken any laws. Just the opposite—striking employees were voluntarily guarding the Pullman works against the type of threat that had brought Brown to the mayor's office.

The first elements of the 15th Infantry arrived at Chicago's Union Station early on the morning of the Fourth of July and were immediately dispatched to several trouble spots. Hopkins later denied that he opposed federal intervention but expressed his irritation at not having been consulted. "I was not advised or counseled…when [the troops] were brought here, and up to that time, nobody had notified me they were not receiving adequate protection.…I never protested against the federal troops, notwithstanding, I felt they should have called the state authorities first."

Hopkins absorbed his share of criticism from those who believed him partial to the union. Little question existed as to where the mayor's sympathies lay, but he showed no favoritism in the performance of his duties. He and his police, many who remained on duty for ten straight days and slept at their station houses, did their utmost to keep an explosive situation from becoming worse. In his and his officers' defense, Hopkins could point to messages of commendation from railroad and stockyards officials.

It was an Independence Day unlike any other in the city's history, before or since. From sunup till sundown, 150 soldiers battled mobs estimated as high as 25,000 at the stockyards. According to Police Chief Brennan, virtually all were troublemakers and thrill-seekers who had no connection to the Pullman strike. "Nothing but extreme forbearance and patience [on the part of commanding officers] prevented a great loss of life," the *Tribune* reported. "Dozens of times soldiers stood with their rifles to their shoulders, their fingers on the triggers, waiting for the word to fire." After a full day of burning and derailing, the rioters began to disperse, their retreat hastened by the arrival of an artillery battery and the famed 7th Cavalry. Reinforcements

were on the way from Fort Leavenworth, Kansas, and other posts. Also that night, a new order went out from army headquarters: any repetition of the trouble would be met by bullets, bayonets, charging horsemen and, if necessary, cannon fire.

While the entire army contingent was tied down at the stockyards, the Grand Crossing neighborhood to the southeast and Blue Island, three mobs totaling more than ten thousand formed along the Rock Island tracks between 39th and 51st Streets. They overturned boxcars, derailed coaches and threw rocks at the police, deputy marshals and railroad employees. They blocked the main line with boxcars and sidetracked entire trains. The following morning, the Rock Island general counsel confronted Mayor Hopkins with a blow-by-blow account, adding that four more trains had been stalled on the main track shortly before his visit. Hopkins, his corporation counsel and the Rock Island attorney adjourned to the railroad's offices, where the president of the line complained that the police weren't performing their duty. Irritated, the mayor replied that his information indicated quite the contrary, so he invited the two rail officials to accompany him on an inspection tour of the trouble zone. Both declined, citing fears for their personal safety. Hopkins and the city attorney, accompanied by Chief Brennan, rode to the scene in an engine provided by the railroad.

The mayor related:

> We found there a large body of people, probably 3,000 or 3,500, composed largely of women and children. On the main track…there were four trains standing which had been there for some hours, and just north of 37th Street there was an empty freight car turned over on its side and lying across the track.…
>
> [A] wrecking crew came along…and they started to take this car off the track. After they had straightened this car out and we had moved on about 100 feet we saw some more cars which had been turned over.…[T]here were probably 12 or 15 cars within the next mile and a half north of there [and] turned over.…The police force, so far as I could see, were doing all they could.

The mayor had seen enough. He returned to city hall and issued a proclamation to the citizens of Chicago along with a written order to Chief Brennan. He prepared the public for a call-up of the militia and hinted at the possibility of requesting martial law. He urged everyone to mind his or her business, avoid places where crowds congregated and "See that all

women and children are kept away from the public streets and railroad tracks." The mayor directed the police to clear the streets and tracks of "every assemblage of persons" and to arrest anyone who disobeyed.

By that evening, Hopkins was beginning to realize that army regulars, special deputies and his police officers required still more help, but he balked at requesting martial law. Learning that a Chicago-based militia regiment was about to depart for Springfield on a training mission, the mayor wired Governor John Altgeld, asking that the troops instead be placed on standby at their local armory. The governor complied. What transpired the rest of the night would further convince the mayor of the need for more help. Throughout the day, thousands of rioters had battled the small detachment of soldiers at the stockyards while other mobs, largely unmolested by overwhelmed police and marshals, overturned boxcars, flatcars and passenger coaches, blocking all traffic on the Rock Island.

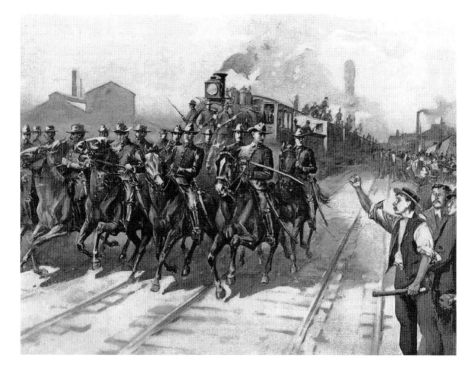

Rampaging mobs set fires, derailed trains and battled police and the military during the Pullman Strike, leaving a dozen dead, 515 arrested and countless injured. President Grover Cleveland ordered regular army troops, including the famed U.S. 7th Cavalry, to Chicago to put down the violence. *Courtesy of the Chicago Public Library.*

"This thing has got beyond a strike," declared General Nelson Miles, the army commander. "It has become a dangerous riot....If it is not dispersed, a grave crisis is before Chicago." As if to prove the general's point, a mob of two thousand tried to prevent soldiers from moving a train at the stockyards. The confrontation led to hand-to-hand combat that ended with a bayonet charge. Only the absence of an officer to issue the order kept the troops from opening fire. As the mob regrouped, it heard the familiar bugle call "Boots and Saddles." The main gate of the army camp a block away swung open, and out came members of the 7th Cavalry, riding ramrod straight. "Not an eye was turned right or left," according to a news account. "Straight toward the rear of the mob they came. They rode straight through the mob without as much as tightening a rein. The horses stepped forward briskly, and the mob scattered like rats…" as the cavalry escorted the train out of the yards.

The riot was far from finished. Mobs continued to overturn boxcars, set fires and destroy every bit of railroad equipment that stood in their path. An out-of-control throng estimated at ten thousand men and five thousand women began an advance along the Rock Island right-of-way toward downtown Chicago. The wave of humanity stretched for nearly three miles. The police were virtually powerless. Then suddenly, without explanation, the numbers of rioters began to shrink and eventually melt away before they traveled much beyond 12th Street at the edge of the central city. Perhaps they'd simply had enough. Whatever the reason, no one felt greater relief than Mayor Hopkins, who had been viewing the mayhem from up close. Finally, the mayor clearly understood that the rioting represented more than his beleaguered officers and the soldiers present could handle.

Hopkins returned to city hall and conferred with his advisors late into the night. There was no more talk of Chicago handling its own troubles. Later in the day, July 6, the mayor wired Governor Altgeld to request five more regiments of militia. Half an hour later, Altgeld replied that the troops were on their way. The callout won plaudits from General Miles, who thus far had been somewhat unclear as to whether he would need reinforcements. Before the trouble ended, nearly the entire Illinois militia—four thousand troops from all corners of the state—had reported for duty in Chicago. Their numbers, along with regular army reinforcements, would lift the total of city, county, state and federal peacekeepers to more than fourteen thousand.

At the same time Mayor Hopkins and the police were trying to keep ahead of the advancing mob, nearly all that remained of the World's Fair buildings went up in flames of undetermined cause. Exhibition halls not yet torn

down had been signed over to a salvage company that hadn't begun work. Flaming debris leaped from one temporary structure to the next until the entire grounds became an inferno of burning cloth, wood and plasterboard. Dead-tired firemen, not needed at the moment to fight blazes on railroad property, could only watch alongside thousands of onlookers attracted by the brilliant spectacle.

On July 8, President Cleveland issued an executive proclamation to Chicago, directing its citizens to cease "unlawful obstructions, combinations, and assemblages and retire peaceably to their respective abodes on or before [noon on July 9]"—or face the consequences. At city hall, in the meantime, Mayor Hopkins pursued his goal of salvaging some form of arbitration, although it was becoming clear that the union's position was weakening by the hour. The newspapers' practice of erroneously identifying arsonists and other criminals as strikers had undermined the already tenuous position of the Pullman workers. At the mayor's behest, four aldermen and three labor leaders from other industries called on Pullman officials to offer a modest proposal: have the company select two representatives, let the circuit court judges name two and, if the four so choose, decide among themselves on a fifth member. Their assignment would not be to arbitrate the strike but determine whether any grounds existed for arbitration. Pullman's vice president for labor relations, Thomas Wickes, treated the mayoral delegation like lackeys before turning down the proposal. "There is principle involved here," Wickes asserted. "We must manage our own business. We cannot allow our employees to do it for us."

Fifty mayors of cities throughout the country declared their support of arbitration, and their spokesman, Mayor Hazen Pingree of Detroit, joined Hopkins in a follow-up call on Vice President Wickes and other company officials to present the petition. Although Hopkins and Pingree were treated more cordially than the previous delegation, they received the same answer. The company knew the strike and the ARU boycott had been defeated and wasn't about to negotiate with a beaten foe.

With more and more trains beginning to roll again, ARU leader Eugene Debs was desperate to save even a little face. About all he could hope for was reinstatement without penalty for the strikers and boycotters. To deliver such a request, he turned to the man who had tried to achieve arbitration and had risked his personal safety to help restore law and order. Mayor Hopkins agreed. He and Alderman McGillen took the communiqué to offices of the railroads' Managers Association and handed it to the group's chairman, Everett St. John, who said, in effect, that since the mayor had brought it over,

he would condescend and share it with the members of his board. Hopkins and McGillen left and learned later that a second railroad executive, John Egan, claimed to have told the mayor that he shouldn't have allowed himself to be a "messenger boy" for the union. Hopkins bristled when told of Egan's supposed comment. "I want to say emphatically that Mr. Egan never said that to me; I don't think I would have allowed him to say it."

It was three strikes and out for the mayor in his attempt at arbitration. When he arrived at his office the following morning, he found the Debs's communiqué sitting on his desk along with a note stating that the Managers Association "will receive no communication whatever" from the union. The note was signed, "Yours respectfully, John Egan."

The strike had been broken. Railroad employees were streaming back to their jobs, and the Pullman Company agreed to take back some of its workers if they agreed not to belong to a union. The company made it clear, however, that the returnees would have to compete for positions with newcomers it planned to hire. Pullman also blacklisted about one hundred employees it considered instigators, including Jennie Curtis and veteran car builder Thomas Heathcote, overall leader of the strike. The list would be sent to other companies far and wide to handicap, if not prevent, the ingrates from obtaining future employment.

By the end of the month, Hopkins agreed to the incremental release of some off the militia, but the troops weren't leaving fast enough to suit Altgeld. The governor sent his adjutant general from Springfield to inspect Pullman and meet with the mayor. "I spent the entire afternoon [July 30] at Pullman," the general reported. "It struck me as being a mighty quiet place." His observation underscored the fact that the town and works had remained free of the violence that wracked other parts of the Chicago area. The following day, Hopkins summoned Vice President Wickes to his office and, in the presence of the general, told the Pullman official that the time had come for the company to supplant militiamen with its own security force. That day, eight companies stationed at Pullman went home. The works reopened on August 2, and by the sixth, all militiamen had been withdrawn from Chicago.

The strike's toll amounted to 12 shot and killed or fatally wounded, 515 arrested and 71 indicted. The exact number of injured was never determined but had to have reached well into the hundreds. Those arrested were charged with murder, arson, riot, assault, burglary and other crimes. Losses to the railroads totaled more than $685,000 ($15.8 million) in damage and expenses and $4.7 million ($108.1 million) in lost earnings.

4

THE BIG CON

John Hopkins emerged from the Pullman strike politically unscathed and, if anything, saw his standing rise in the eyes of the public. He'd stood up for working men and women, repeatedly tried to reason with an intransigent employer, treated the company and the railroads with respect and even-handedness and managed, with plenty of outside help, to restore sanity after the worst rioting in the city's history. The leadership qualities detected by William Stead had been on full display. But at some point over the following six months, another side of Johnny's character would take over or become subsumed by the designs of Roger Sullivan and others. First, though, came the fall election of 1894, which, as in most elections, offered a number of fascinating sideshows.

Sullivan decided to leave his post as clerk of the probate court and shoot for the patronage-laden job of Cook County clerk, where he could increase the number of Hopkins-Sullivan foot soldiers. Roger won the nomination, while Johnny threw the weight of the party's city organization behind the full Democratic state and county slate. Hopkins ignored complaints that the mayor of Chicago had no business interfering in county and state affairs. He heard gripes that he was building a Tammany Hall–style juggernaut, which, according to a *Tribune* editorial, "Is fully as bold and thorough-paced [in terms of] election frauds…and interference in state and federal elections as the New York original." What Hopkins chose not to ignore was a Republican campaign circular that, in so many words, accused his machine of selling protection to gamblers in return for campaign

contributions. Less than a week before Election Day, Hopkins filed suit for criminal libel against John R. Tanner, chairman of the Republican State Central Committee. The mayor insisted that election eve politics had nothing to do with his action. "My private character has been attacked," he wailed. The GOP literature did not accuse the mayor of pocketing tainted money, but it came close. It charged him with "blackmail…upon the vices of the city of Chicago" to provide campaign funds to interfere in county, state and federal elections. Tanner sloughed off the lawsuit and, ultimately, so did the courts. Three years later, Tanner, as governor, would sign legislation highly beneficial to Hopkins-Sullivan. The checkerboard, as Roger liked to say, was always moving.

At the time of the November 1894 election, Carter Harrison II and his brother, Preston, were running the financially strapped *Chicago Times*. They were desperate to win the contract for printing the list of delinquent taxpayers, a job that would bring approximately $60,000 and bail them out of a hole. The decision to award the printing contract fell to the county treasurer. If the Democrats captured the office, the Harrisons reasoned, the contract should go to one of the city's two Democratic papers, the *Times* or the *Herald*. It's been said that all any politician wants is a fair advantage, and the Harrisons saw themselves at a definite disadvantage. Politically connected banker John R. Walsh, owner of the *Herald*, was a close friend of Mayor Hopkins, and it's been said, in Chicago, it's not what you know, it's who you know. Hopkins also owned stock in the *Herald*, a fact presumably unknown to the Harrisons at the time.

"My brother and I entered into a huddle of two," Carter Harrison wrote in his autobiography, *Stormy Years*. They determined that "the one and only way" to assure just treatment would be for Carter to run for treasurer and, if he won, award the printing contract to the family newspaper. "Heroic remedies," he rationalized, "were indicated if the *Times* were to be assured of fair play in the distribution of the spoils." That constituted one definition of fair play from a man who spent much of his long life railing against the evils of the Hopkins-Sullivan machine.

Carter Harrison swallowed his pride and sent an emissary to Hopkins to reveal his treasurer ambitions. The mayor and local party chieftain made a counter-proposal—run for sheriff instead—"also a lucrative office," Harrison conceded, "even if not so promising for a newspaper." But Harrison also saw a sinister motive in Hopkins's offer. He realized that Eugene Prendergast, his father's assassin, was in county jail under sentence of death, awaiting the outcome of his appeal. If the sentence were upheld, an

outcome considered all but certain, the decree would be carried out by the next sheriff. The prospect "of a son acting as executioner of his father's murderer" left him repulsed. Harrison turned down the offer, and Hopkins secured the treasurer's and sheriff's nominations for others. The gamesmanship hardly mattered. The entire Democratic ticket took a drubbing. Roger Sullivan, the party's one local winner four years earlier, fell particularly hard, but he had a consolation prize in mind.

Chicago's boodling aldermen probably considered the rioting that accompanied the Pullman strike a welcome distraction from what they were about. During the hot, tumultuous summer of 1894, two factions, scheming independently of each other, readied separate sandbag ordinances to drop on the city council. One ploy originated with Governor Altgeld's ubiquitous in-law and law partner John Lanehart. Sometime in the spring, Lanehart drafted a detailed ordinance granting rights, privileges and a fifty-year franchise to a new company that would compete with the reviled gas trust, now controlled by the even more reviled Standard Oil Company.

He began by lining up the necessary capital on Wall Street as well as support in the council. One of the first heavyweights he sought out was Roger Sullivan, who, according to Kogan and Wendt, "planted the idea of getting rich in the gas business with Mayor Hopkins." Thinking he had the ducks

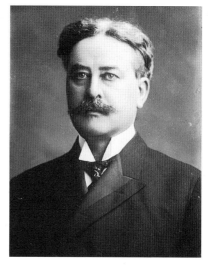

Carter Harrison II, like his father a five-term mayor, often came out on the short end of seemingly endless intraparty battles with Hopkins and Sullivan. *Courtesy of the Chicago Public Library.*

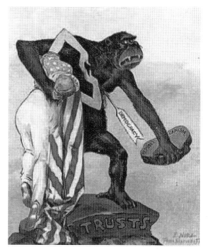

Reviled by the public, trusts represented a popular target for good government crusaders. Chicago's gas trust proved no exception. *Courtesy of the Chicago Public Library.*

in a row, Lanehart stood ready to unveil his proposed ordinance when he learned of the other scheme. Passing two sandbag measures at or about the same time demanded more chutzpah than even the council's pocket-stuffers could muster. Lanehart agreed to defer, assured by the other faction that his turn would come, and he could count on the votes.

Introduction of sham ordinances generally created an uproar among the honest aldermen, the public and the press. The arrival of the proposed Universal Gas franchise proved no exception. Alderman Bathhouse John Coughlin, posturing these days as a reformer, denounced the measure as speculative and dishonest. "Who are the promoters?" Coughlin demanded to know. "Why don't they come out in the open and say what they want? There ain't nobody going to believe this franchise will ever build a genuine company! It's gonna be sold down the river!" Clearly, the Bath hadn't been cut in yet.

The Universal Gas measure passed overwhelmingly with some reputable aldermen swallowing the line that this mystery company would take on the trust and lower gas rates. Alderman Little Mike Ryan guided the ordinance through the July 16 council meeting, which ran past midnight. Hopkins insisted he had never heard of the measure until he reached the council chamber and vowed to veto it. At the time, his motives appeared altruistic.

The mayor's lengthy veto message, read by a clerk at the next council meeting, brimmed with righteous indignation. Lanehart supposedly drafted the words. Hopkins condemned "Lawless organization[s] of so many quasi-public corporations [built] upon watered stock, the attempt to earn and declare dividends upon mere wind, and the consequent extortions practiced upon the public." He also blasted as excessively long the fifty-year term of the franchise. His "most persistent inquiries," the mayor said, "have failed to ascertain a single capitalist who would father this company. And the records disclose that with the exception of a few shares the entire capital stock has been subscribed by a lawyer's typewriter." He got the latter part right. Papers filed with the secretary of state listed an A.M. Horn as the subscriber of all but $300 of Universal's $5 million in capital stock.

A.M. Horn turned out to be Anna Horn, a legal secretary who notarized the articles of incorporation. A downtown attorney named Charles Francis admitted being one of three $100 stockholders acting as figureheads for the true owners. "I am a stockholder only as the paid attorney for the parties who are behind the scheme," Francis disclosed. "Who the parties are I am not now at liberty to say." The mystery took on an added quirk when it came to light that Francis and one of his partners were on riot

duty with the state militia on the day they supposedly were completing Universal's incorporation.

During the week between the Universal vote and Hopkins's veto, Alderman Coughlin professed to have learned the identities of the backers. The Bath had undergone another conversion and now joined those set to override. "I have seen the [Universal] promoters," Coughlin told his colleagues. "Within 30 days they will have begun construction of [their] plant. It will be but a short time before the promoters will announce themselves."

The mayor had played his part well, knowing all along that Universal's promoters had the votes to override his disingenuous veto. Thus, Universal Gas began its short life. The gas trust soon shelled out a reported $170,000 to make this nuisance go away. Hopkins, Sullivan, Lanehart and their confederates now waited to repeat the scenario, but they had a much larger dollar figure in mind.

With little more than one month remaining in Hopkins's term and the mayor not seeking reelection (for reasons that soon would become clear), it was now or never for the brainchild of the Lanehart-Sullivan-Hopkins crew. They drew a ring around the date for the city council meeting on Monday night, February 25, 1895. Until deep into the lengthy agenda, the session dealt with mundane housekeeping. Thirty-eight times the aldermen approved the construction of sidewalks in various parts of the North Side. Members introduced seventy-one individual initiatives, calling for, among other items, a permit to string a banner across Blue Island Avenue and 12th Street, along with another permit for construction of an optometrist's thermometer on Randolph Street. Even the most civic-minded left in the audience must have suppressed a yawn or three. Only a limited number of insiders knew what was coming later because the names Ogden Gas and Cosmopolitan Electric, companion sandbags, appeared nowhere on the agenda.

Mayor Hopkins was given to nervous mannerisms during council meetings. William Stead wrote, "His fingers are continually playing with his mallet, and at times even this method of disposing of his surplus energies fails and he gets up and walks backwards and forwards like a caged lion on the raised dais on which the mayoral chair is placed." This night, the mayor appeared even more nervous than usual.

The boys had rehearsed. Hopkins ducked out early. Carter Harrison later claimed that the mayor got cold feet. Other accounts have him excusing himself to attend the theater. Perhaps both accounts are correct, but his early exit seemed to fit the plan. The mayor turned the gavel over to

Alderman Little Mike Ryan who immediately recognized his Gray Wolf cohort, Alderman John McGillen. The latter moved to take from the file of old council business an ordinance granting a franchise to a Norwood Construction Company to build an electricity generating plant. McGillen then produced, like the proverbial rabbit out of a hat, a finely detailed four-thousand-word ordinance that obviously had taken some legal brain considerable time and effort to draw up. The document, no doubt Lanehart's springtime handiwork, granted a fifty-year franchise to a mysterious Cosmopolitan Electric Company. McGillen moved its substitution for the Norwood ordinance. One honest alderman rose to a point of order, claiming that Cosmopolitan represented a brand-new matter, not a substitution that could be considered in this fashion. He was voted down.

Similar moves to have the ordinance deferred met the same fate, and the Cosmopolitan Electric Company, about which absolutely nothing was known, won approval for a half-century franchise by a margin of 38–22. The spread would have been greater, but the ringleaders excused some kindred spirits who were facing difficult reelection battles. Cosmopolitan won the right "to construct, maintain and operate a plant or plants," tear up streets, build tunnels under the Chicago River and run lines to deliver electricity.

The council meeting moved along like a choreographer's dream. Ryan handed off the gavel to McGillen, who recognized Alderman Powers. "Johnny de Pow" moved to resurrect an ordinance granted to a City and County Gas Company. This entry was originally introduced by co-conspirator Tom Gahan three years earlier. One alderman objected on the grounds that no such ordinance appeared in the record of the council proceedings. His motion, too, was tabled, and Powers moved to substitute an ordinance granting a franchise to an Ogden Gas Company. Another attempt to derail the runaway express failed, and the Ogden measure triumphed by the same tally as Cosmopolitan Electric. A third ordinance, granting a franchise to an Excelsior Power and Heat Company—the name was changed later—was taken from the file but not moved until a council meeting a month later. The boys probably figured enough was enough for one night. Carter Harrison speculated that the Excelsior measure was "Just an arrow shot into the air to bring possible good fortune at a propitious time in the future."

Not only were the Cosmopolitan and Ogden votes identical, but the length, style and language of the two documents were remarkably similar as well. One of the aldermen who sought at least some modification observed, "These ordinances were drawn by the same attorney, and I would not wonder if they were made one a carbon copy of the other, written by the

same stenographer on the same typewriter." Like Cosmopolitan, Ogden won the right to construct plants, tear up the streets and place pipes under the river for a fifty-year term.

Both measures were, in fact, drawn up primarily by Lanehart, who had incorporated the companies in Springfield only the previous Saturday. Lanehart identified himself as the attorney for Ogden but wouldn't reveal who was back of the venture. Nor would Albert Tyrell, Cosmopolitan's lawyer, say anything about his clients. Tyrell listed himself as one of four incorporators in the official filing, but all were understood to be acting as fronts, as were the four individuals named in the Ogden filing.

Speculation over who stood behind Ogden and Cosmopolitan immediately became the city's newest parlor game. The names of the usual suspects surfaced, and some of the papers went so far as to suggest the mayor himself might be involved. A bit of time would elapse before all the identities became known. Duplicate ownership of the companies was divided into eleven shares. Because of his critical role, Hopkins received two, with one each going to Sullivan, Lanehart and Gray Wolf Aldermen Powers, Ryan and the two Toms, Gahan and Byrne. Attorney Levi Mayer, who helped with the drafting and council strategy, came in for a share, as did Patrick Sexton, millionaire brick company president and general contractor, whose credits included city hall, the Cook County Building and Cook County Hospital. A Democrat, but also a business associate of Republican boss Billy Lorimer, Sexton was later indicted on charges of attempting to defraud the federal government in a construction deal. Lorimer never was part of the original scheme, presumably because Republican help wasn't needed at that point. Sullivan would require his counterpart's aid a little later when the game moved to Springfield. The final one-eleventh represented a pot to buy council votes and meet other incidentals. Votes reportedly sold for $1,000 apiece.

Lanehart held his share in trust for Governor Altgeld, who inherited it upon his law partner's death in August 1896. The governor's in-law was believed to have coined the name Ogden Gas Company. One account held that he had participated in a number of successful real estate transactions with a partner named Ogden and hoped the name would continue to bring good luck. Another possibility suggests the name of Chicago's first mayor, William B. Ogden, himself a real estate speculator and legendary deal maker.

Confronted by the press, Sullivan and Altgeld were adamant in their denials, while McGillen was somewhat more forthcoming. Roger branded

Pardoning alleged participants in the 1886 Haymarket Square bombing spelled the political undoing of Governor John Peter Altgeld, suspected of holding a hidden interest in Ogden Gas. *Courtesy of the Chicago Public Library, Special Collections and Preservation Division.*

it "foolishness" to suggest that his friend the mayor had any connection with the companies. He went on to deny his own involvement, then added a bit of circumlocution. "I will admit I am willing to own such valuable franchises…but unfortunately, I am not interested. I know nothing whatever of the Cosmopolitan Company. As to the Ogden Company, I have heard a little gossip, not of a reliable nature, however. I have no means of knowing who is back of it."

Questioned about Ogden, Altgeld maintained, "I know absolutely nothing. I should judge from what you tell me that Lanehart, as an attorney, has been getting out articles of incorporation for some company. He has a right to do anything of that sort…such work is part of an attorney's business."

McGillen claimed to know nothing of Ogden but admitted that he introduced the Cosmopolitan ordinance to help some unnamed friends. "[I]t afforded me great pleasure to be able to assist them.…I got up out of a sick bed to go to the council meeting to help put the Cosmopolitan ordinance through."

Hopkins defended the measures in general terms to reporters who caught up with him but declined to reveal whether he would endorse or veto them. The morning after the votes, the mayor and a party of family and friends hopped a train to New Orleans. The size and diversity of the group strongly suggest that the trip was planned well in advance and, in all likelihood, timed to get His Honor away from a week's worth of more bothersome inquiries. The mayor would return just in time for the next council meeting while keeping Chicago guessing about his action on the controversial matters.

During the intervening week, the newspapers exploded in outrage. "It was the most disgraceful night in the history of the city's disgraceful legislative body," the *Chicago Record* charged. The *Chicago Journal* stated, "There is not a particle of doubt in the mind of anybody not an imbecile that the gas and electricity ordinances rushed through by the grace of John P. Hopkins…

are crooked." The *Chicago Post* predicted that "the public soon would learn the identity of the fellows who put up the job, now concealed by a host of nobodies probably procured at small cost to act as decoys."

Reaction played out on two additional fronts. In Springfield, state representative S.L. Lowenthal, a Chicago Republican, introduced a resolution calling on the speaker of the house to appoint a committee to investigate the council vote and, if the measures were found to have been passed illegally, ask the attorney general to quash them. In Chicago, the Civic Federation organized a mass protest meeting on the Sunday afternoon prior to the next council session. Five thousand turned out at the Central Music Hall, designed by renowned Chicago architect Dankmar Adler and built on the corner of State and Randolph Streets in 1879 "to promote religious, educational and musical purposes." (The building manager led religious services there on Sunday mornings.) Attendees at the federation's meeting came filled with a religious zeal that had little to do with traditional worship. Another two thousand who couldn't squeeze in attended a hastily arranged overflow rally at the Second Regiment Armory and heard from the same set of speakers. Federation president Lyman Gage had dampened rumors that the attendees would hear sensational charges against men in high places. Instead, the crowds listened to a parade of civic leaders denounce the legislation and advocate reform of municipal affairs. The speakers scored the council for granting unknown parties the right to tear up public thoroughfares and called on Mayor Hopkins to impose his veto to protect the public interest.

As cries for reform filled two packed venues, the mayor and some of his party were aboard a train bound for Chicago, following a pleasant week in the Crescent City. Hopkins had been accompanied by ten friends and family members. The group included his sisters, Adelia and Kate; Roger Sullivan's wife, Helen; and Mrs. Daniel Corkery. Roger remained in Chicago, awaiting Johnny's return. Mrs. Corkery's inclusion quite possibly demonstrated one of Hopkins's better qualities—never forgetting a friend. Her husband, one of Johnny's early supporters for mayor, died not long before. Maybe the New Orleans excursion offered a way of alleviating her grief while saying posthumous thanks to her late husband. Mrs. Corkery, Mrs. Sullivan and the Hopkins sisters left New Orleans to spend a few weeks in Honduras. The others, including a past and present member of the Hopkins cabinet, returned to Chicago with the mayor. At Centralia, Illinois, the party gained an unexpected—and most certainly unwelcome—addition—a *Tribune* reporter. That morning, an editorial in the paper, citing "those in a position to know," predicted that the mayor would sign both ordinances:

"True, Mr. Mayor?" asked the reporter.

"When I left Chicago, I requested [the] *corporation counsel to carefully examine the ordinances and report to me on my return as to whether the interests of Chicago were properly protected....As to what my action will be, I cannot say until I have a conference with* [the corporation counsel]. *"*

"Public sentiment seems to be running strongly in favor of a veto."

"I always listen with respect to the opinions of the citizens of Chicago....I appreciate that my final action will be fully criticized either by the friends of the holders of the present franchises [the gas trust] *or by the citizens who are demanding cheaper light and power, but I will discharge my duty without fear or favor."*

In other words, Hopkins seemed to be saying that the true rationale behind the creation of Ogden and Cosmopolitan was a desire to give the public cheaper utility rates. What else could it have been?

"Do you know who is in back of the ordinances?"

"I have not the slightest idea."

When Hopkins got home, he found Sullivan waiting for him in his, Hopkins's, bed, according to *Tribune* writer Clifford S. Raymond. "Mr. Sullivan...knew where he might reasonably depend upon finding His Honor the mayor, not possibly as soon as others who waited, but certainly more privately." Raymond seemed to suggest that Roger wanted to strengthen his friend's resolve to sign the ordinance before someone else could talk him out of it. What are we to make of this alleged encounter, which Raymond mentioned nearly twenty years after the fact, within the context of a lengthy profile of Sullivan? He offered no further details. How did the newsman learn of it? From one of the two men or a third party one of them had confided in? Hopkins had filed or threatened to file libel suits in the past but said or did nothing in this instance. Neither did Sullivan.

Mayor Hopkins was back at his city hall office early the next morning. He immediately huddled with the corporation counsel and his personal attorney. When the meeting broke up, the mayor was handed a message from a three-member committee appointed at the Central Music Hall rally. The members requested an appointment to present the anti–Ogden and Cosmopolitan and council reform resolutions adopted at the meeting. Hopkins performed his best rope-a-dope; of course, he'd be glad to see the distinguished gentlemen any time, at their convenience. Around noon, the committee members arrived for an hour-long, closed-door meeting. When

the members emerged, they reported that the mayor declined to state his intentions, telling them that he would reveal his position in a message to the council that night. Hopkins also received visits from Ogden conspirator Tom Gahan and John McGillen and Little Mike Ryan, the pair who steered the ordinances through the council the previous Monday. Like as not, they reviewed signals for this evening's installment. Before the meeting, the mayor enjoyed a quiet dinner with Roger Sullivan.

Perhaps the most and maybe the only surprised person in the chamber was corporation counsel John Mayo Palmer. The mayor publicly stated that he would be guided largely by Palmer's opinion. Palmer spent all day Sunday preparing a veto message and delivered it to his boss, fully expecting it or a reasonable variation to be read to the council. Hopkins completely disregarded it. The mayor, once again highly nervous, read a statement approving the Ogden ordinance. His private secretary paced back and forth below the mayor's rostrum to coach him on parliamentary procedure in a meeting turned raucous. Opposition aldermen who rose to be heard drew cheers from the gallery but were gaveled down by Hopkins and shouted down with curses from Ogden supporters. The mayor banged his gavel like a carpenter driving nails, and his threats to clear the gallery soon became irrelevant. His words were frequently met by hisses from the audience as he proclaimed himself a champion of reform, bent on attacking a gargantuan gas trust and delivering lower rates to the public. He denounced "moneyed princes who pose as reformers," an apparent swipe at Lyman Gage and the Civic Federation. Once again, he claimed not to know who stood back of the Ogden Company. It seemed quite possible, he offered, that responsible people were involved. But on the other hand, if suspicious circumstances existed, it was for the voters, not him, to pass judgment on the aldermen. After all, no one should expect the mayor of the city to become involved. Ogden gained final approval by a wider margin than it did the previous week—43–18.

On to Cosmopolitan Electric. The mayor read a message upholding the ordinance while tacking on a few cosmetic amendments. The chamber was filled with so much shouting that scarcely anyone could hear the changes. Cosmopolitan passed by the same margin as its sibling.

"The people will veto this entire gang…" shouted honest Alderman John O'Neill, to cheers from the gallery and profanity from aldermen seated nearby.

The council hurriedly disposed of some minor matters, then, as if by prearrangement, an alderman in the "anti" bloc—likely someone who'd

been given a pass—moved for adjournment. "All in favor," said the mayor. "All opposed." And it was finished. Hopkins donned a yachting cap and ducked out of the chamber to meet Sullivan and celebrate their triumph and one other occasion with a night at the opera. The City of Chicago turned fifty-eight years old that day.

Among those present at the council meeting were gambling boss Billy O'Brien, who sat near his partner, Alderman Powers. Not far away sat John Lanehart, who listened to the script he had helped prepare. It appeared obvious, according to the *Chicago Record*, that the mayor hadn't had time to prepare and have printed his long message during the period between his return from New Orleans and the council session. The paper said Hopkins admitted that he'd had help from Lanehart and Clarence Darrow, attorney for Cosmopolitan. That a noted liberal reformer such as Darrow would represent a sham company created by con artists perplexed many in good government circles. The most plausible explanation was that Darrow so despised the gas trust that he would use any weapon available to fight it. As for the unsuccessful draftsman, corporation counsel Palmer, rumors of his immediate resignation swept city hall. However, Palmer scotched the talk and remained in the Hopkins cabinet.

The morning after, Mayor Hopkins ranked as Public Enemy Number One. "The city has more to fear [from the mayor and his gang]," the *Daily News* proclaimed, "than from the cutthroats, thugs and assassins who haunt the dark corners and alleys of the Levee at midnight." Marshall Field, the department store impresario, said, "I think that Mayor Hopkins' action was wrong and I do not see how any man can say otherwise." Henry Evans, president of the Commercial Bank, added, "I am certain that the people of Chicago are righteously indignant at such an unwarranted and reprehensible use of power. A revolution in municipal affairs is certainly coming." The mayor turned aside inquisitive reporters, telling them he had nothing more to say. Alderman

Noted liberal crusader Clarence Darrow confounded many in good government circles when he became attorney for one of the sham companies created by the Ogden Gas plotters. *Courtesy of the Chicago Public Library.*

Powers, one of the few Ogden-Cosmopolitan supporters to surface at city hall, offered a similar response. The most talkative official proved to be Palmer, who denied any bad blood between him and the mayor. Palmer asserted that he didn't feel slighted and saw no reason to resign. Sullivan once again denied any connection with the ordinances. Asked whether he knew who was behind them, he said, "I do not and what's more I don't care a snap what becomes of them, any more than I cared last Monday night whether they went up or down."

Two days after approving the measures, Hopkins became more talkative, saying he would welcome a legislative investigation. "I cannot say I know of corruption, nor have I any facts now in my possession that would throw light on the matters to be investigated, but I will do all in my power to assist the committee in getting at the facts." The mayor also delivered a warning to his critics. He'd been keeping a file of everything said about him since taking office, and unless some unnamed persons retracted certain statements, they might face a Hopkins lawsuit.

The first in a series of moves and countermoves that would last more than a decade came just days after the companies got the green light from the mayor and council. A pair of civic leaders, acting as private citizens and taxpayers, filed suit in superior court to restrain the entities from using the city's streets and alleys. The men alleged that the ordinances were obtained by fraud. In dismissing the suit two weeks later, the judge agreed that passage had been defective, to say the least, but that jurisdiction lay with the county state's attorney or state attorney general. Hopkins capitalized on the ruling to perform the last official act of his term, the issuance of permits to Ogden and Cosmopolitan to tear up streets and lay pipes. Each permit was issued late at night, though both the mayor and his public works commissioner denied any attempt at subterfuge. Before departing for Springfield to attend a Democratic State Central Committee meeting, Hopkins told a reporter he understood Ogden would soon break ground for a gas plant, and no, he still couldn't divulge the names of the people behind the company.

Little Mike Ryan could read the cards as well as the next alderman. With the April 2 municipal election approaching, Little Mike, a prime mover of Ogden and Cosmopolitan, announced that he wouldn't be running. He undoubtedly made a wise decision. Only two council members who voted for the ordinances won reelection out of ten supporters who sought another term. Another six backers took Ryan's path and chose not to run, leaving only twenty-four of the original thirty-eight-member majority in

the new council. For all the good it did, Hopkins supported his onetime Democratic opponent, drainage board president Frank Wenter, for mayor. Wenter absorbed widespread attacks as a tool of Hopkins and Hinky Dink Kenna. "Take the covering from Mr. Wenter," a Republican leader inveighed, "and you will find beneath the mark of the men who have voted away the city's franchises to greedy corporations." Wenter faced off against another candidate Hopkins had defeated in '93, former alderman and interim mayor George Swift. Given up as politically dead fifteen months earlier, Swift clobbered Wenter by more than forty thousand votes. With a squeaky-clean occupant entering the mayor's office and fresh, reform-minded members joining the city council, future prospects appeared uncertain for Ogden and Cosmopolitan.

Throughout Hopkins's term, Alderman James Mann had stood as one of the council's few voices for honest government. Mann was particularly vocal in the futile attempts to block Ogden and Cosmopolitan, enduring jeers and curses from the majority. Now, he prepared to extract a measure of revenge. At the first meeting of the new body, Mann introduced ordinances to repeal the status of the twins, plus that of Excelsior, or Commercial, as it now was called. He argued that no contract could exist between the companies and the city because the ordinances had been illegally passed. Not so fast, said Ogden attorney and stakeholder Levi Mayer. Ogden's ordinance "has been properly accepted, a [$100,000] bond filed, a $20,000 cash deposit made, a permit has been issued, property [acquired near North Avenue and the North Branch of the Chicago River for] the works and a contract made for the purchase and laying…of pipe." Mayor Swift didn't require a trip to New Orleans to consider the matter. He signed each repeal that night, his first as mayor, before he left his chair. A few days later, Swift ordered the revocation of the companies' street permits. Attorney Mayer complained anew, emphasizing that both the federal and state constitutions prohibit the passage of an ordinance that impairs the execution of a contract. Typical of the way the Ogden drama would play out, nearly a year would elapse before Mayer and the company went to court seeking to have the bans overturned.

April 8, 1895, marked the last day in the short, mostly happy mayoral life of John P. Hopkins. Johnny made a farewell tour of city hall, shaking hands with everyone from department heads to clerks and janitors. Many of his well-wishers appeared visibly affected. When the mayor returned from making the rounds, throngs converged on his office. Mayor-elect Swift was an early caller, and the two reviewed plans for the evening's swearing-in ceremonies.

John Hopkins was tired, physically and emotionally. One month after leaving office, the ex-mayor sailed for Europe aboard the *Teutonic*, accompanied by his former corporation counsel Harry Reubens and the attorney's daughter. (Reubens also traveled with Hopkins to New Orleans.) Completing the little entourage was Father Francis Clement Kelly of Holy Family Church, so if needed, Johnny could avail himself of spiritual as well as legal advice. Presaging Greta Garbo, Hopkins declared "that one of the chief reasons I wish to get away is so that I may be let alone." Far from public indignation over Ogden Gas and Cosmopolitan Electric, he might have added. He mentioned that this was his first real vacation since he was ten years old. "I've worked all my life, and I think I have earned a rest." His primary destination was a spa at Ems, Prussia, where he spent three months seeing doctors and taking the waters for a chronic throat condition. Following the lengthy stay, which included weeks-long periods of not speaking, he pronounced himself cured and traveled on to Frankfurt, Liverpool and, of course, Ireland.

Roger Sullivan did something oddly contradictory when he submitted his personal information for inclusion in the 1895 Chicago City Directory. The entry for his residence identifies him as a "Capitalist" living at 842 Walnut. The line below lists his business affiliation as "Ogden Gas Co. Elmer Allen Kimball, Pres. Charles J. Ford, Sec. 1031-79 Dearborn." The listings appeared about the same time Sullivan was stoutly denying any knowledge of or interest in Ogden Gas. Records show him serving as secretary of the company in 1897 and 1898 and secretary of Cosmopolitan Electric as well in the latter year. Tom Gahan is listed as president of Ogden in 1897–98 and president of Cosmopolitan in '98.

The true identities of the other members of the Ogden-Cosmopolitan combine gradually emerged. Hopkins's involvement ranked as an open secret, but nowhere did his name appear as an officer or director. In October 1895, the ex-mayor and John Lanehart traveled to New York, where they were joined by Levi Mayer, who was returning from Europe. The ostensible purpose of the trip was to put the finishing touches on the consolidation of Ogden and the gas trust, although Lanehart denied it. He said he was in New York to arrange financing for the construction of Ogden's production plant. How did he explain Hopkins's presence? The former mayor, Lanehart claimed, had come east to see a Philadelphia throat specialist. Evidently, the German doctors had not cured him. Hopkins went to Philadelphia each morning and returned to New York in the evening, Lanehart told a reporter. If Hopkins was seeing a doctor in Philadelphia, the logical question

presented itself: why was he staying in New York? To keep me company, the gubernatorial in-law explained with a straight face. "[I]t was really unkind for me to ask him to come to New York with me, but I didn't like to be here all alone. I'm very sorry Mayor Hopkins isn't here, but he is in Philadelphia." A newsman reported that he heard "a deep cough from a masculine throat" from an adjoining room in Lanehart's suite.

John Lanehart came full of denials. He insisted that Hopkins had nothing to do with Ogden and that he, Lanehart, had no intention of selling the company's franchise. In a curiously personal choice of words, the lawyer said, "When Mayor Hopkins gave me the franchise I told him the mains would be laid and the gas piped into them....I've put $150,000 into land for the plant." Lanehart continued, "I can't say I've ever received a proposition from the gas trust to sell out....I might have been approached by a broker who had seen the gas trust people and asked them what they'd give and then asked me what I'd take. You know brokers have a way of doing that. But as for selling out to the gas trust, that thought has never entered my mind."

Lanehart, his private thoughts notwithstanding, kept waiting for the right offer. Months rolled by. Coming up on one year since the city revoked Ogden's construction permits, the company, in the person of Levi Mayer, went to court to get them back—and play another card in the game with the gas trust. Ogden won this round. Less than three weeks after Mayer's petition, a judge accepted his argument that the city lacked the legal authority to negate the ordinances, especially after Ogden had put up the cash deposit and spent six figures to acquire land for its plant. The judge did narrow Ogden's request for authority to tear up streets across the North Side. He required the company to work on a limited basis under the supervision of the city's public works commissioner. Renewed permits in hand, Ogden proceeded to do something no other sandbagging utility had ever attempted. The company actually built a gas plant on the land purchased by Lanehart near the North Branch of the Chicago River and laid mains to homes and businesses within its service territory. Other sandbag operators had laid mains, a news commentator wryly observed, but they ran exclusively into the gas company's treasury. Not only did Ogden establish itself, it engaged Peoples in a price war as well. Whether Hopkins, Lanehart or the rest of the cabal ever dreamed this day would come is open to debate. Carter Harrison claimed, "There was no idea in the minds of [Ogden's] backers that the rights would ever be fully exercised. From time to time, the thumbscrews would be applied sufficiently to show the existing

gas companies the dangers of allowing a company to exist with potential power to enter on embarrassing competition."

To Peoples Gas, the competition did, indeed, become embarrassing. The company consistently saw its prices undercut by Ogden in the section of the North Side where they competed head-to-head. Ogden's goal remained acquisition by the larger company, not necessarily becoming the provider of choice. Peoples grew weary of the game and negotiated a contract with its junior competitor under which Ogden not only gained exclusive territorial rights but received a fee from Peoples for staying on the reservation, so to speak. Fortunate consumers in Ogden's domain found themselves paying 10 percent less than their Peoples counterparts.

The no-compete contract bound the companies through mid-1900, but in the spring of 1897, Roger Sullivan, Tom Gahan, Billy Lorimer, Charles Tyson Yerkes, the Peoples Gas operatives and an accompanying host of manipulators saw the planets come into alignment with the arrival of the most corrupt legislative body in Illinois history. Republican John R. Tanner, once unsuccessfully sued by Hopkins, moved into the governor's office. "The price of legislators was as freely discussed at the Leland Hotel [the favored Republican watering hole] as the price of hogs at the stockyards," the *Times Herald* noted. Altgeld later claimed that he had turned down a $500,000 bribe offer from Yerkes to approve a fifty-year franchise for the traction king's street railways. But with the prickly Altgeld out of office and facing political, financial and physical decline, the Chicago crowd prepared to do business with one of their own. Governor Tanner was a Lorimer ally who had risen through the party's ranks. After he became chairman of the Cook County Republican Central Committee, Lorimer provided crucial assistance to help Tanner win the nomination for governor.

Yerkes had his own agenda for advancing his transit schemes, while Sullivan, with Lorimer's help on the other side of the aisle, conspired with his Peoples counterparts to achieve the ultimate goal of consolidating the gas companies. Yerkes's most important franchises were due to expire in six years, and he feared an aldermanic feeding frenzy before he could get them renewed. With a reported $500,000 slush fund at his disposal, the traction king began the quest for the Holy Grail of street railways and public utilities—the half-century franchise. "Having framed such legislation, Yerkes now cheerfully set about the business of bribing the legislators to pass it," wrote Samuel Insull biographer Forrest McDonald. "He reckoned that the price would be high; after all, he was bribing politicians to pass laws that would make it unnecessary for him to bribe them again." A second

The Peoples Gas Building at the northwest corner of Michigan and Adams, headquarters of the powerful utility targeted by the Ogden cabal. *Courtesy of the Chicago Public Library, Special Collections and Preservation Division.*

The Illinois State Capitol in Springfield, in a later photo, where legislators' votes were bought and sold like "hogs at the stockyards," according to one news account. *Courtesy of the Chicago Public Library.*

explanation held that a rising tide of reform would reduce crooked Chicago aldermen to a minority after the next election. In other words, it was now or never for Yerkes.

His first attempt, the Humphrey Bill—named for the Lorimer underling who introduced it—was quite straightforward; it enabled city councils to grant fifty-year franchises. Introduction generated a public outcry, and the bill got defeated on the floor of the House. Yerkes bounced back with a bill introduced by a representative named Allen from downstate Hoopeston, "a country village of a few hundred inhabitants, without even a bobtailed car drawn by a mule as representing street railway

interests," in the words of a Chicago civic leader who fought the bill. The traction king's intention remained the same, but the tactics became more nuanced. Proponents argued that longer franchises were necessary to secure investment in public infrastructure that required long-range planning. "Any person knows," Lorimer reasoned, "that a corporation can afford to pay more in the way of compensation for a 50-year franchise than it can for a 20-year franchise." The Allen Bill seemed quite innocent when introduced in the House. One particularly farsighted feature provided for establishment of a state commission to regulate utilities. After the Allen Bill reached the state senate, it got amended to include the cherished fifty-year franchise provision that had gone down with the Humphrey Bill. Again, public and editorial outrage erupted, this time to no avail. The legislature passed the measure, and Governor Tanner signed it into law. Sullivan and his allies immediately saw the opportunity for yet another sandbag job, but first came the need to pass the Gas Frontage Act and the Gas Consolidation Bill. Back in Chicago, Hopkins couldn't be blamed for thinking that this once-impudent Republican Tanner might not be such a bad fellow.

The Gas Frontage Act put so many roadblocks in the way of forming new companies that competition became practically impossible. Wags described the measure as "The Eternal Monopoly Bill." The *Times Herald* charged that the bill was "essentially intended to protect the gas trust and its new ally, the Ogden Gas Company, in uninterrupted possession of the privilege of supplying [gas] to Chicago at an exorbitant rate....Such a measure was sought by no one but the gas people." Its companion, the Gas Consolidation Bill, did what the title suggested—permitted the consolidation of gas companies while granting them certain purchase and leasing rights. Both bills won approval and were signed by Governor Tanner, but they later were found unconstitutional by the courts before Ogden and Peoples could take advantage of them. Civic activists who battled the legislation charged that rank-and-file legislators received $1,500 each for their votes in favor of the gas bills and $3,500 for the transit measures. Legislative leaders were paid more, it was alleged.

On the electric side of the ledger, Sullivan and a group of about a dozen Gray Wolves moved quickly to take advantage of the Allen Law. On June 21, 1897, with the ink barely dry on Yerkes's masterpiece, the city council voted overwhelmingly to grant a fifty-year franchise to a phantom Commonwealth Electric Company. The scenario reminded one and all of March 25, 1895, all over again. No one knew the beneficiaries, the franchise ran too long, the city's

take was too small and proposed charges to consumers too high. Differences in ownership probably explain why the Wolves decided to form a new dummy for a sandbag job rather than fall back on Cosmopolitan and its active fifty-year franchise. Sullivan had a stake in both companies, but not all of the same aldermen were involved. Elections had shuffled the council lineup twice since the passage of Ogden-Cosmopolitan. Some of the Cosmopolitan holders who weren't part of the new scheme reportedly offered good wishes to their successors. The new players didn't need the friendly encouragement. The council approved the Commonwealth Electric ordinance over the veto of Mayor Harrison, 46–19, the only time in five terms of office that the younger Harrison failed to sustain a veto.

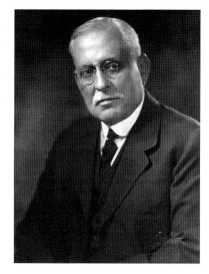

One of the few public figures to outwit the Hopkins-Sullivan combine was Chicago Edison president Samuel Insull. Insull thwarted a shakedown attempt then became a personal friend of Sullivan. *Courtesy of the Chicago Public Library.*

Before they created Commonwealth, the politicians gave Chicago Edison president Samuel Insull an offer he couldn't refuse. They figured that they could shake him down for several hundred thousand or maybe even a million dollars to prevent the creation of a competitor with a fifty-year citywide franchise. When confronted with the proposal, Insull stormed out of the meeting, and soon afterward, Commonwealth Electric was born. But Insull enjoyed the last laugh. Chicago Edison held exclusive rights to buy the equipment of every American electrical manufacturer. Generating stations, not legal documents, produce electricity. Insull's patent licenses rendered the stick of potential competition nonexistent, but the carrot—the long-term franchise—offered a once-in-a-lifetime opportunity. The wily Insull offered to take the dummy company and its only asset off the hands of his would-be blackmailers for a nominal sum. Sam Insull Jr. old biographer McDonald years later that his father paid $50,000, but a company report filed with the city put the amount at $170,000. Either way, the franchise acquisition represented both a coup and a bargain. With the repeal of the Allen Law by the legislature in 1899, Chicago Edison stood as the only electric utility in Illinois with a franchise of more than twenty years. Yerkes, who had put

the game in motion, was left empty-handed to consider his next moves. In 1907, Chicago Edison and Commonwealth Electric merged to create the Commonwealth Edison Company.

Contentiousness, like politics, can breed strange bedfellows. Sullivan and Insull each saw something of the other that they liked. Both were products of modest upbringing, only in their thirties, outsiders determined to grab all that Chicago and America could lay before them. Once the Commonwealth Electric sale had been concluded, Insull invited Sullivan to his home for dinner, and their relationship blossomed. In his memoirs, Insull fondly wrote of a time years later when Roger and Helen Sullivan and their family were visiting London. The Edison chief invited them to visit at his country estate and meet his parents, who also were visiting. "The acquaintance of Mr. and Mrs. Sullivan with Mrs. Insull and myself," he remembered, "drifted in the direction of closer personal friendship. My mother and Mrs. Sullivan were very fond of one another....Roger C. Sullivan was a man of great natural ability, and one of the greatest aids to his success was his wife...a far seeing yet lovable woman."

With their attempt at consolidation stymied by the courts, Ogden and Peoples went back at each others' throats. Their no-compete contract was due to expire in mid-1900, so Ogden got a leg up by declaring another price war. It announced plans to sell $10 million in bonds to build a second and third plant and challenge Peoples citywide. Some called the move a bluff to boost the company's eventual sale price, but a New York syndicate did buy $5 million of the bonds. Peoples got the message. The two companies took a page from the 1895 playbook. With almost no advance notice, friendly aldermen introduced an amendment to the Ogden franchise, permitting the company to consolidate with another and not forfeit the franchise. In a riotous city council meeting on June 18, the amendment won approval. A perplexed Mayor Harrison was leaving for New York the following morning to be at the bedside of his brother, Preston, who was facing major surgery. Carter vowed to "veto that amendment and make it stick if it is the last act of a misspent life!" But if the surgery didn't go well and Harrison couldn't return for the next week's council meeting, the amendment would become effective immediately. The mayor was appalled that the sponsors timed their move to coincide with the Harrison family crisis. He raged against being dragged from "the possible deathbed of an only brother," but the operation proved successful, and the mayor returned in time for the meeting. As promised, he exercised his veto and made it stick.

Traction had represented a flashpoint in Chicago municipal affairs for three decades, and Harrison set out to make the issue his own. He felt a right of inheritance. In 1883, Carter I had extended the franchises of three city streetcar lines for twenty years as a compromise to fighting the companies in court over a technicality in their ninety-nine-year franchises, granted in 1866. Early in his term, Carter II and a team of reform-minded aldermen departed Chicago after Monday-night city council meetings for Springfield to lobby against the Humphrey Bill. After that measure lost, to be supplanted by the victorious Allen Bill, the action shifted back to the city council, which now enjoyed the right to bestow fifty-year franchises. As noted, Sullivan struck quickly in June 1897 to gain a fifty-year franchise for Commonwealth Electric over Harrison's veto. Yerkes realized the folly of trying to duplicate this success too soon afterward, so he let the traction wars cool while he took an extended vacation in Europe. Another plot line suggests that he hadn't been able to buy enough votes from aldermen fearful of too much, too soon.

By now, Harrison had concluded that under tighter municipal governance, the streetcar lines could generate increased compensation to the public treasury, reduce taxes and freeze, if not reduce, fares. Such a strategy meant head-on confrontation with C.T. Yerkes, a man not accustomed to losing. Harrison viewed the challenge as daunting but loaded with potential returns from grateful straphangers. "For better than a decade," the mayor wrote, "[Yerkes] had bestridden the local financial world, a veritable Colossus. His name synonymous with success; for years he had dominated city hall affairs, a master whose word was undisputed." Yerkes's mastery of the business community, the mayor claimed, derived from stock ownership in his City Railway Company. Some of Chicago's biggest names—Marshall Field, Samuel Allerton, Levi Leiter and their "millionaire associates"—could be numbered among the shareholders, according to Harrison. The major City Railway investors, the mayor implied, used the company as a conduit to put up a share of the bribe money used to gain the fifty-year extension, "letting Yerkes bear the onus of the dirty work,"—in other words, spreading the money around the city council.

By December 1898, the traction king was ready. He maneuvered his fifty-year extension into the council. Harrison called on the public to descend on city hall for the next meeting. "If Yerkes can pass an ordinance over my veto, I'll eat my old brown fedora," the mayor boasted. The fedora remained intact; his veto wasn't needed. By a single vote, Harrison managed to get the ordinance assigned to a friendly committee where it would die a lingering but certain death. Kenna and Coughlin sided with the mayor, opting for his

continuing benign neglect of the Levee over the offer of Yerkes's largesse. The decision must have been tough for the Hink and the Bath, but they had the future to consider over the promise of immediate gain. With Harrison riding high, Hopkins and Sullivan remained largely on the sidelines of Democratic Party affairs throughout 1898.

After repeal of the Allen Bill, his defeat in the city council and facing two more years with an implacable foe in the mayor's office, Charles T. Yerkes decided to call it quits. Harrison claimed that an additional factor came into play: "Yerkes' partners in many a shady deal found him a liability." The final breach occurred, according to the mayor, when Yerkes made a secret contract to enrich himself at the expense of his partners, who, when they learned of it, called the traction king on the carpet.

"What are you going to do about it?" Yerkes reportedly demanded. After the shouting died down, one nationally prominent financier accused Yerkes of committing a criminal offense and insisted on restitution. "Unless you cancel this outrageous contract, I'll see that the penitentiary doors close behind you."

Harrison said Yerkes stood, stared in turn at each man at the table and told them, "You may succeed in sending me to the penitentiary, but when I enter its doors, you, and you, and you," indicating several men, "will accompany me. I know many things about you, gentlemen, things it would not be nice for the world to know; I shall not hesitate in case of necessity to take the authorities and the public into my full confidence." He picked up his straw hat from a table where it lay with others, turned back toward the chastened businessmen and said, "I never saw so many straw hats at a funeral! Good day, gentlemen!"

Yerkes supposedly pocketed $4.5 million from his erstwhile partners for his remaining shares in their transit enterprises. The onetime Chicago Colossus settled in London, invested heavily in the construction of the city's Underground and died there in 1905 before netting a return on his stake.

The gas war resumed. Peoples organized a dummy company to invade Ogden's turf and undercut its rates. The dummy, which leased its gas and mains from Peoples, became necessary so its creator wouldn't have to lower rates throughout the city. Ogden responded by staging a few shams of its own—a series of mass meetings to denounce the rates charged by its sometime suitor, sometime competitor. Prominent speakers, well meaning but naïve, addressed these "spontaneous" gatherings of citizens concerned about the high price of gas, unaware that the man who was orchestrating the proceedings from behind the curtain was Roger Sullivan. The grand finale

occurred on September 27, 1900, at the Central Music Hall, where more than five years earlier, protestors had gathered to urge Mayor Hopkins to veto Ogden Gas and Cosmopolitan Electric. If this flourish demonstrated Roger's flair for the ironic, it stood as a gem.

By the fall of 1900, the Peoples-Ogden courtship was back on again. The companies signed an agreement under which Peoples acquired Ogden for $7 million. The *Tribune* editorialized, "Nobody will be any better off for this war except the persons who have succeeded in holding up the 'Gas Trust' and compelling it to buy a plant which it did not need." The editorial went on to say that in the end, the public would pay for all the chicanery in higher gas bills.

Just when it appeared the Ogden story was over, state's attorney Charles Deneen filed a surprise suit, charging that the legislative act under which the consolidation was to take place already had been declared unconstitutional. The suit wound its way through the courts and was finally upheld by the Illinois Supreme Court in December 1903. Undeterred, Sullivan understood that the legislature can giveth what the courts taketh away. He lobbied long and hard on behalf of two new bills crafted to overcome the legal objections to gas company consolidation. The morning after the first measure passed, with assurances of the governor's signature, Roger bumped into a Chicago alderman while crossing the Adams Street Bridge. The two exchanged "good mornings" and shook hands. The unidentified alderman, having read the morning paper's account of legislative victory, said gleefully, "You'll be putting more than your mitt in my fist before long." The prediction proved accurate. After the Sullivan forces secured passage and enactment of the second bill, the Ogden Eleven split the jackpot. Each share carried a value of approximately $660,000, or $15.2 million in 2017 dollars, with Hopkins getting double. The wait had been long—more than a decade—but very profitable.

Sullivan left the gas business and, with his brothers, formed the Sawyer Biscuit Company on the West Side. Roger became president, a continuing source of mirth for the papers, which sometimes referred to him as "The biscuit maker." The Sullivans laughed as they put lots of money in the bank; the cracker and biscuit manufacturer proved highly successful. Roger continued to carry the title of secretary of the Cosmopolitan Electric Company for a number of years, even though Cosmopolitan never did generate any electricity. Not surprisingly, Sullivan looked back on his Ogden years much differently than did the newspapers and good government

people. "What damage," he asked, "did the Ogden Company ever do to the city of Chicago? Was it a fraud? Did it or did it not sell gas? Did it or did it not reduce the price of gas?" Fair questions, the answers to the latter two being yes and yes. A contrarian could ask, "Wasn't the company's primary, if not sole, purpose to enrich a select group of political insiders? Wasn't passage of the Ogden franchise a product of subterfuge and bribery? Didn't Hopkins, Sullivan, Altgeld, Lanehart and others lie early on when they claimed to know nothing of the company or its supporters?"

The sudden death of Thomas Gahan in 1905 shed further light on the grand scheme of February–March 1895. Gahan's estate included five hundred shares of Peoples Gas, valued at $57,680 ($1.5 million), two hundred Ogden Gas bonds worth $170,000 ($3.4 million) and virtually the entire capital stock of Commercial Heat and Power, the third and nearly forgotten sandbag job—Harrison's "arrow shot in the air." The arrow never hit a target; the shares were deemed valueless. John Hopkins and Congressman Martin Madden served as executors of the Gahan estate. Madden's tie to Gahan and Hopkins is of particular note because he was the Republican leader of the city council at the time Ogden and Cosmopolitan were approved. He was absent from the council on "private business" the night they were passed and the following week when Hopkins sustained their passage.

One poignant footnote marked the Ogden affair. Money problems forced former governor Altgeld to sell the share he inherited from John Lanehart, reportedly for a mere $36,000. The purchaser was a wealthy, retired First Ward pawnbroker named Jacob Franks, a friend of Harrison, Kenna and Coughlin. Franks enjoyed a King Midas reputation; everything he touched turned to gold. And so it happened with Ogden Gas, which ended up netting him more than $600,000 ($13.8 million). But Franks's luck took a tragic turn in 1924 when his fourteen-year-old son, Bobby, was murdered by Nathan Leopold and Richard Loeb. In a final ironic twist, Clarence Darrow, onetime Cosmopolitan Electric attorney, saved Leopold and Loeb from the gallows in what came to be called "The Trial of the Century."

5

THE RISE OF THE
BLOND BOSS

No one ever questioned John Hopkins's ability to turn a phrase. In many instances, he used his eloquence to tweak or bludgeon an opponent. When not playing political hardball, he could prove capable of speaking diplomatically, even compassionately. One such occasion arose when former governor John Peter Altgeld, "The Little Dutchman," died of a stroke on March 12, 1902, at age fifty-two. Altgeld was stricken after delivering a speech in Joliet, Illinois, in defense of the Boers' fight against the British in South Africa. The diminutive campaigner went out the way he'd lived much of his life, his supporters were quick to note, battling for the underdog. Hopkins said,

> *He was the greatest man of his generation....He was not the radical man most people supposed him to be. While he was governor, there was not a radical piece of legislation enacted in Illinois. When he pardoned the anarchists* [accused of the Haymarket bombing], *he was asked to do it by the largest and best petition ever presented a governor by any state. His hatred of President Cleveland grew out of Cleveland's action in sending federal troops to Illinois without consulting him. It was a natural anger, and the governor was right in his protest.*

The Democrats' state convention three months later in Springfield cast Johnny in an altogether different light. The mundane early proceedings offered no hint of what was to come. Delegates approved a slate of

candidates for clerk of the supreme court, treasurer, superintendent of public instruction and three University of Illinois trusteeships. The excitement began at a caucus of delegates from the First Congressional District, where former mayor Hopkins and incumbent mayor Harrison clashed head-to-head for the state central committeeman's post. Even though Harrison didn't live in the district, he prevailed. After the vote, the mayor made his way to the center of the Dome Building rotunda, where he was approached for an interview by *Chicago American* reporter James O'Shaughnessy. Hopkins, described as pale, nervous and excited, spotted the pair and advanced toward them. Other accounts have Hopkins and Harrison clasping hands, but O'Shaughnessy, the only reporter present, denied that either reached for the other's hand. All narratives agree that Hopkins was steaming. The *Tribune* version, apparently gleaned from other bystanders, had him shaking his fist, talking rapidly and so loudly that he could be heard throughout the building.

> *"Did you say that I used boodle in the First District contest?" the ex-mayor demanded of the incumbent.*
>
> *"I said that the only way you could win would be by the use of boodle," Harrison replied.*
>
> *"You said in interviews published in the newspapers that I used boodle to secure my position as chairman of the Democratic State Central Committee. Let me tell you to your face you are a little pinhead. You never earned an honest dollar in your life outside of your position as mayor and the salary it brought you. The money you have got was extorted from gamblers and harlots and from graft and the sale of franchises. It all came from the vice of Chicago and was wrung out of that element. When you ran a newspaper, you blackmailed Democratic candidates, and if they did not give you the money you wanted, you brought your paper out against them."*

Bystanders stood dumbfounded to hear a former mayor address the sitting mayor this way in public. Harrison remained calm, bordering on indifferent.

> *"I said that only by the use of dishonest methods could the district be carried by you," Harrison maintained.*
>
> *"Will you repeat that in the convention—what you have said?"*
>
> *"I'll do as I please," the mayor replied coolly.*
>
> *"I want you to repeat that in the convention so that I can answer you."*

"I will answer for my own affairs in my own way. I repeat what I have said, that if you carried the district caucus it would be by methods that an honest man would not use."

"You talk of boodle, you who have never earned an honest dollar in your life."

"You are pretty sore now."

"Yes, I'm sore. Why wouldn't I be sore to be lied about in that way?"

"Have a care now."

"I am a man of substance and property," Hopkins shouted. *"I am responsible for what I say, and I know what I am saying. If you believe I libeled you, all you have to do is go into a court of justice, and we'll find out whether I have or not."*

"What I said I still stand by," Harrison answered. *"I have not a word to retract."*

"You have threatened to go on the floor of the convention and talk about me," Hopkins said. *"If you dare to open your mouth in this convention about me, I will get up on the floor and tell the delegates what I know about you and repeat what I am telling you now."*

Hearing the commotion, hundreds of delegates surged around the adversaries, fully expecting blows. One of the arrivals, Roger Sullivan, stepped between the pair, grabbed Hopkins by the arm and pushed him back.

"Let me alone," Hopkins said to his partner, "I'm talking to this man." As Sullivan and an unidentified man escorted the former mayor away, Hopkins added. "I only want an opportunity to tell what I know about that fellow. I would be delighted to have him say in the convention the cowardly things he said behind my back."

Harrison moved away from the encounter without assistance, never having lost his composure. "I said what I believe to be true, and I have nothing to retract," he repeated.

Some news reports stated that Hopkins used "strong" or "harsh" language, probable euphemisms for profanity. Correspondent O'Shaughnessy said that didn't happen. In Harrison's files, along with the news clippings of the dust-up, can be found a signed, one-paragraph, typewritten memo from the *Chicago American* reporter—a deposition of sorts. There is no indication why or to whom it was written. In answer to an inquiring editor, perhaps? A memo to file? A response to a Harrison request? O'Shaughnessy wrote:

The newspaper clipping in the foregoing is from the Chicago American *evening edition of June 17* [1902]. *The account printed in the morning edition, June 18, has some unwarranted alterations. The typewritten lines* [interspersed with newsprint] *are inserted to include some sentences that I overlooked in the hurry of writing to catch an afternoon edition immediately after the occurrence. Neither disputant held the other's hand, and there was no "stronger" language used in the colloquy than quoted in the foregoing. I was…the only reporter who was present during the affair. All of the account of it in the foregoing is correct as I remember it.* [Signed] *James O'Shaughnessy.*

Hopkins delivered the last blow of the battle at the convention. Denied the district committeeman's slot by Harrison, he went on to win an at-large spot by vote of the full convention over the vigorous opposition of the mayor's forces. Hopkins not only won that contest but also predicted he would win the state party chairmanship, a boast made true a few days later.

The showdown at the Dome Building rotunda had legs, as news people like to say, so reporters sought out both participants as soon as they arrived back in Chicago. A fresh controversy turned on whether or not Hopkins called Harrison a "pinhead." The mayor said he didn't remember being called that name; others present said Hopkins used that term, among stronger epithets. His opponent's only truly offensive remark, Harrison claimed, was the charge that he, the mayor, never earned an honest dollar. "I cared nothing for his blow and bluster, nor his threats," Harrison continued. "Will I sue him for libel? O, no. What would be the use? I have been a good Democrat all my life, which is more than Mr. Hopkins can truthfully claim."

When Hopkins's turn came to replay the incident, a reporter asked why he didn't punch the mayor. "That would have been a disgraceful thing to do," Johnny answered. "I guess the young man knows what I think of him and that's enough. I wanted him to make the charges in open convention that I was boodling my way into the state committee, but he showed himself to be too much of a coward."

Upon further reflection, Harrison concluded that Hopkins did not call him a pinhead. "He may have intended to do so, but he did not do it."

The war of words may have ended in a draw, but no doubt remained as to who was running the state party. Harrison's attempt to stop Hopkins from becoming state chairman failed badly, as Johnny received twenty-five of the thirty-two votes cast by committee members.

The machinations of Chicago and Illinois politics have frequently confounded outsiders and even some supposed insiders. After Richard Nixon's election as president in 1968, his administration, following longtime custom, began replacing high-level Democratic appointees with Republicans. One of the most prominent Chicago-area Democrats to feel the axe was Thomas Foran, the highly capable U.S. attorney for the Northern District of Illinois. According to protocol, the task of recommending a successor to the president fell to the state's senior Republican senator, silver-haired, silver-tongued minority leader Everett McKinley Dirksen. Not long after Dirksen had chosen a worthy successor, Foran and the senator had a chance encounter. Foran approached Dirksen and assured him that he held no hard feelings. "I understand," Foran said. "That's politics."

Dirksen replied, "No, Tom, you don't understand. Only two people in Illinois truly understand politics. One is your great mayor, Dick Daley, and modesty prevents me from mentioning the other."

Roger Sullivan understood politics. He spoke openly about relations between the various Democratic and Republican factions. "[S]ometimes they are enemies and sometimes they are friends…The checkerboard is moving all the time…and the men who are strong enemies today may be friendly six months from now." Guided by that philosophy, Sullivan turned to Billy Lorimer in 1908 to hatch a swap. Roger would encourage Democrats to vote for Republican presidential candidate William Howard Taft over William Jennings Bryan, the Democratic nominee making his third try for the White House. Sullivan had no problem with the switch of allegiance because he and Bryan detested each other. In return, the "Blond Boss" would steer Republicans to Democrat Adlai Stevenson I for governor to the detriment of the incumbent Republican, Charles Deneen. Lorimer's love for Deneen matched that of Sullivan's for Bryan.

Billy and Roger saw an opportunity to undercut rivals who operated far outside their own party orbits. Lorimer held Deneen in particular disdain. Eliminating him, then possibly manipulating the septuagenarian Stevenson to his and Roger's mutual benefit, offered an attractive outcome. The *Tribune* once characterized Lorimer as

One of the first to recognize that in the business of politics there were no such things as parties. Sentimentalists to whom patriotism, principles and loyalty were living ideals might be influenced by a party appeal, and to that extent the party "myth" was useful, but between practical businessmen seeking their material welfare in politics this was silly twaddle and not to be considered.

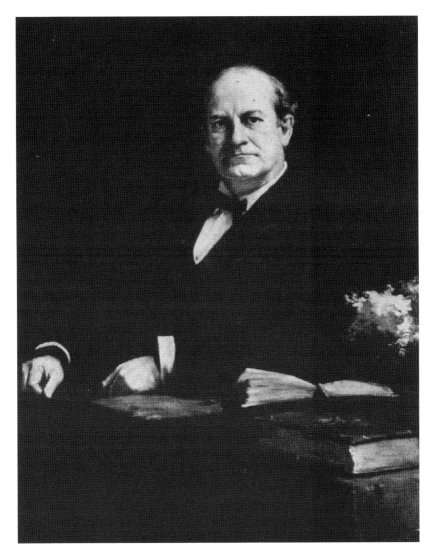

Three-time presidential candidate William Jennings Bryan, Woodrow Wilson's secretary of state, detested Roger Sullivan. The feeling was mutual. *Courtesy of the Chicago Public Library.*

Evidence of the Sullivan-Lorimer scheme appeared by chance. Governor Deneen and Republican state chairman Roy West were coming out of an office in downtown Chicago when they ran into a curious quartet exiting a nearby office. Before them stood Roger Sullivan, Billy Lorimer,

former Republican governor Richard Yates and Kankakee Republican powerhouse and future governor Len Small. The parties barely managed an acknowledgement before heading for separate elevators. Deneen and West surmised that Roger hadn't taken their fellow Republicans to a tall building to show them an overview of the city. Their suspicions mounted as reports to GOP headquarters throughout the state brought examples of interparty horse trading. Lorimer's forces, with the help of the Sullivan people, provided Stevenson with mailing lists of Republican voters, which the Democratic candidate used to send personal appeals for support, postmarked from his hometown of Bloomington.

Attempting to capitalize on anti-Sullivan sentiment downstate, the Republicans mailed letters describing Roger, not Stevenson, as the true candidate. Forget about Adlai, the mailings advised; if he won, Illinois would be governed by Hopkins and Sullivan. Why, the *Tribune* wondered editorially, did Stevenson never mention Bryan's name in any speech? Nothing bearing the Nebraskan's name had been forthcoming from the state central committee, why? Why were Hopkins, Sullivan and their allies ignoring the national ticket altogether? In answer, the paper claimed, "Every Democrat in Chicago" knew the Hopkins-Sullivan machine was exchanging Bryan votes for Stevenson votes, "notoriously playing for local offices at the expense of the national ticket." Good questions, good answer, but coming from a newspaper that would as soon see Bryan, Stevenson, Hopkins, Sullivan, Brennan, Powers and quite a few more relegated to some desert isle, if not Siberia, the faux concern was transparent.

The vote swapping amounted to a colossal failure at the county level but showed a definite impact on statewide voting patterns. The Republicans captured every county office. Deneen lost in the city but narrowly took the county, running well behind his local ticket mates. A big Republican push downstate was needed to nudge him across the finish line and thwart Stevenson, Sullivan and Lorimer. The impact of the two bosses' vote trading became obvious in the tallies. GOP presidential candidate William Howard Taft carried the state by 175,000 votes compared with Deneen's victory margin of 30,000. Republican state chairman West complained, "Mr. Sullivan made the most bitter fight in the history of the state in his effort to defeat Governor Deneen. He sacrificed everything, everyone on the county and national tickets for Mr. Stevenson....He stopped at nothing. By these tactics, supplemented by the expenditure of enormous sums of money, he succeeded in reducing Governor Deneen's plurality. For Governor Deneen to have been defeated...would have been

a scandal and a disgrace to the state." Roger offered a more succinct election night reaction: "It seems to me that the wisest thing to do is to be silent."

The premise that those outside Illinois don't fully grasp the state's frequently byzantine politics was no more apparent than three years later when Deneen was called to testify at a U.S. Senate hearing into Lorimer's election to that body:

> *Senator William Kenyon, Iowa:* "*Were* [Roger Sullivan and William Lorimer] *working together on this matter* [to defeat you in 1908]*?*"
> *Deneen:* "*That was the impression—the public impression. There was no doubt of it in my mind.*"
> *Senator Wesley Jones, Washington:* "*Of course, Mr. Sullivan would oppose you, because he was a Democrat?*"
> *Deneen:* "*They did not make that distinction.*"
> *Jones:* "*You do not have distinctions such as that up in Illinois?*"
> *Deneen:* "*Well, not altogether.*"

In 1909, the six-year term of Republican U.S. senator Albert Hopkins (no relation to John, though occasionally confused with him) was expiring, and several aspirants were jockeying to unseat him. The decision would fall to the Illinois legislature, since the nation remained five years away from the popular election of senators. As soon as the balloting got underway on January 19 and 20, word leaked that friends of Senator Hopkins had created a $35,000 slush fund to buy the votes of seventeen Democrats for $2,000 apiece. Hopkins maintained, probably truthfully, that he knew nothing of the scheme. The plot fell apart when Sullivan, Lorimer and Republican House Speaker Edward Shurtleff stepped in. Shurtleff had just been elected Speaker with significant Democratic help. Lorimer was already working against Hopkins in the hope of coaxing his, Lorimer's, antagonist, Governor Deneen, to take the spot, move to Washington and hand the governorship to a Lorimer ally. If that scenario didn't work, well, Billy himself, a congressman at the time, could take a shot at the Senate seat. An angry Shurtleff summoned the two Democratic bagmen and threatened to expose the Hopkins plot from the speaker's chair. If they persisted, he warned, he would interrupt the roll call and tell why each Democrat voting for Hopkins was doing so and how much each was getting paid in return.

About this time, Sullivan received a phone call in Chicago from his Springfield confidante, who relayed these developments. Roger boarded the

6:30 p.m. Chicago and Alton bound for the capital, arriving shortly before midnight. Accompanied by the state party chairman, he went directly to the St. Nicholas Hotel, where he found twenty-seven Democrats who had been assembled in a room by his man on the scene. To call the session a come-to-Jesus meeting might be an understatement. Some of those present paraphrased Roger's tongue-lashing: "I will break every bone in the political body of each and every one of you men if you sell out to Hopkins. You can't deliver yourselves for him. I won't have it. You shan't take any dirty money offered you to vote for him." He thundered that any Democrat who supported Hopkins would be exposed and drummed out of the party.

Roger had made it abundantly clear that he didn't want Albert Hopkins, but who did he favor? Publicly, he endorsed the Democratic candidate, Lawrence Stringer. Whispers in the cloakroom, however, suggested that he and Lorimer were discussing a pact if, in fact, they hadn't already concluded one. Democrats backing their party's choice, Stringer, had a hunch that more curious developments were yet to surface. They wondered whether Roger's urgent trip to Springfield wasn't made to protect Stringer but to keep Lorimer's options alive.

The Blond Boss was pursuing Option One—getting rid of Charles Deneen as governor by offering him the Senate seat. A lot of interests that Deneen had managed to anger—Ogden Gas, the electric utilities, the railroads and many others—also wanted him gone. "They were willing to kick me upstairs or kick me downstairs," the governor remarked later.

During the winter of 1909, Lorimer and the governor held a number of conversations to discuss party and government matters. During their dialogues, the Blond Boss allowed as how he didn't favor Senator Hopkins's reelection. Deneen proceeded cautiously. He and Lorimer discussed possible successors without deciding on a course of action. Billy stopped beating around the bush and urged the governor to go for the seat. Lorimer promised strong support from his Democratic friends. Deneen hesitated. In following days, several state senators and an ad hoc committee pleaded with the governor to run but to no avail. For one thing, Deneen maintained, he didn't want to turn the governorship over to Lieutenant Governor Oglesby, someone he mistrusted. Lorimer countered that Oglesby could be enticed to resign in return for a federal post, and a mutually acceptable state senate president, chosen by Deneen, could be elevated to governor. Deneen continued to resist, knowing that the game afoot was intended to get rid of him, not enhance his political career. Finally, in March, a group of Republicans whom the governor considered his friends convened a meeting

in a Springfield hotel room to form a committee to elect him senator. "I heard of it at eleven o'clock that night," said Deneen. "[We] got 43 of them in the next morning at the office and put an end to it….I told them I would not only never do that, but if I happened to be elected, I would never accept it. [T]hey were going to elect me and let me resign and have a sort of bipartisan affair….I told them I would not accept the position in that way or be used in that way."

The deadlock in the legislature dragged on. Former governor Richard Yates, in town to work for Lorimer's election, called the proceedings "an absolute joke. Everybody voted for everybody else. I think there were about 150 of us who got one vote apiece. It got to the point where the papers had cartoons representing senators as saying: 'I vote for that bald-headed man up in the gallery. I vote for that messenger boy coming down the hall.'"

By late May, word got around that Lorimer, who had yet to enter the race, was about to make his move. He'd been lining up support since the beginning of the month and claimed to have spoken to every member of the general assembly. Lorimer was known throughout Illinois politics as someone who kept his word and would do a favor for a Democrat as readily as he would for one of his own party. Consequently, Democrats regarded him as almost one of their own. He could claim more friends in the other party than anyone—Democrat or Republican.

After Hopkins failed to win on the ninety-fourth ballot, Lorimer figured his time had come. Politicians from across the state, like migratory birds sensing a change in seasons, descended on Springfield the night of May 25 to watch the anticipated climax. The gathering of the flock was likened to a gala social event. When members of the Senate filed into the House chamber at noon on May 26, the galleries were filled to capacity. Speaker Shurtleff ordered the floor cleared of anyone not a member of the legislature. Lorimer stood by in the Speaker's room, where aides kept him informed of minute-to-minute developments. Stringer and Sullivan sat together in the gallery. For more than two and a half hours, the venerable chamber rang with oratory, much of it devoted to pious explanations of a member's vote. The legislature "heard ugly charges flung about in innuendo and half-veiled insinuations," the *Tribune* correspondent reported. "It heard the cry of treachery and hints of corruption. It heard one statesman call another a liar, a cur and a coward and invite him outside the sacred precincts to deadly battle."

The Senate roll call ended with Hopkins in command, garnering thirty-one votes to Lorimer's twelve and seven for Stringer. Before the House vote

began, Representative Lee O'Neil Browne, a Democrat and Lorimer's primary tactician, rose to lavish praise on a "model man" whose "word is as good as a gold bond," supposedly to justify Democratic votes for the Blond Boss. "The people of this state want results," Browne declared. "You cannot cash dreams, and you cannot cash hopes." One Democrat after another voted for Lorimer, as did a number of Republicans who abandoned Hopkins. When his turn came, Democratic representative George English from far southern Illinois recalled Browne's words and challenged the pro-Lorimer Democrats to explain the full reason for their votes. "We are told that you cannot cash dreams and you cannot cash hope," English shouted. "What can you cash in this legislature? Votes?" His words, though perceptive, meant little—about as much as the telegrams that John McGillen, Cook County Democratic secretary, who knew a thing or two about buying and selling votes, had sent to party legislators, threatening punishment to any who failed to support Stringer. The Democratic Senate candidate sat with Sullivan for two hours and watched the Lorimer steamroller push on. "All I know," Roger said later, "is some of these [Democrats] were voting against [Stringer], and I sent a messenger down for one of them, and rather sternly I said I wanted him to vote for Stringer, notwithstanding what certain other fellows were doing."

Roger may well have been putting on a show for Stringer, one that had about as much effect on the rank-and-file as English's words or McGillen's telegrams. Speaker Shurtleff cast the 101st vote for Lorimer, one short of the total needed for election. Last-minute switches brought the total to 108. Shurtleff banged the gavel, and after 95 ballots and more than four months of deadlock, Congressman William Lorimer was elected junior senator from Illinois. The voting breakdown demonstrated Lorimer's claim to the title "Mr. Bipartisanship." He received 55 Republican and 53 Democratic votes, avoiding the embarrassment of receiving a majority from the "opposition" party. Senator Hopkins, once on the cusp of victory, finished with 70, Stringer with 23. That Roger Sullivan, supreme leader of the Illinois Democratic Party, could deliver a mere 23 of 201 votes cast suggested that the checkerboard was indeed moving.

The onetime Chicago streetcar conductor emerged from Shurtleff's quarters and took his place before the body that had just elected him. Wearing a double-breasted coat with a rose pinned to a lapel, the Blond Boss presented the model of humility. He expressed his gratitude at "[r]eceiving the votes of the two great parties…[which] is, of course, a new precedent in the history of this great commonwealth." He promised his "Democratic

friends that the day will never come when I will fail to appreciate the great honor you have helped to confer upon me." Peace, harmony, brotherhood. Could Illinois be entering a new, enlightened era? The state and nation would find out not long after Billy Lorimer's installation, made retroactive to March 4, 1909, another Chicago birthday.

Lorimer capped his election to the Senate, the crowning achievement of a career in politics, with a move that he believed would crown a series of shrewd financial investments. He formed a partnership with a downstate Litchfield banker named William Munday to launch a chain of Illinois banks that would have its control center in Chicago. Lorimer's primary function would be to attract high-profile investors along with government deposits. Munday wrote a letter to hundreds of Lorimer supporters, inviting them to become stockholders in the new banks at $125 a share. The response was enthusiastic, according to Professor Tarr. "They understood the potential profits in political banking. Some of the takers were lawmakers, including Democrats, who had voted for Lorimer for senator." Although the stock already had been fully subscribed, the letter explained, sufficient reserves had been set aside for members of the legislature who still wanted to participate. The fledgling operation was just beginning when the *Tribune* spoiled the grand opening festivities in a very big way.

The practice of paying cash to news sources has long provoked controversy among journalists. "Checkbook journalism" was no less controversial in 1910 than it is today. Providing monetary gain to snitches, tattletales or whistle-blowers is and was regarded with disdain by many in the business of gathering news. An obscure downstate member of the Illinois House learned that lesson when he unsuccessfully approached at least three publishers with his personal account of how he was bribed to vote for William Lorimer for U.S. senator. He finally found a taker at the *Tribune*.

In the summer of 1909, Charles A. White began writing an extensive manuscript that told of his role in the bribery scheme. For some unknown reason, perhaps to release some inner muse, he also included his stabs at poetry and homespun philosophy. The package presented a curious mix, to say the least. *Tribune* editor-in-chief James Keeley spiked the poetry and philosophy but paid White $3,250 for the exposé after sending out a team of reporters and investigators to verify the essential elements of the allegations. "Democratic Legislator Confesses that He Was Bribed to Cast Vote for Lorimer for United States Senator" topped all seven columns of the April 30, 1910 front page. The story, along with photos of the principals, filled the first two pages and a number of sidebars inside.

A short editorial urged Cook County state's attorney John Wayman to "Strike While the Iron Is Hot."

In his own words, White told how he was approached by House Democratic leader Lee O'Neil Browne of Ottawa. White said he had confided to Browne earlier in the session that he was strapped for cash. Browne replied that "if things worked out all right," White "would be able to make a little money out of the session." On the night of May 24, 1909, White was drinking with two friends in the room they shared at the St. Nick when Browne came calling. The minority leader invited the junior member to his room, where Browne asked White whether he could vote for Lorimer. White, who had been voting for Stringer on every ballot, said he could. Browne checked White's name off a list and said "he would depend on me," the back bencher remembered. A payoff amount wasn't discussed, but Browne assured him "it wouldn't be any chickenfeed." The following day, Browne promised White $1,000 up front for his vote and almost that much a few months later when the "jackpot" got divided. The term *jackpot*, as White explained in his narrative, represented money put up by people or corporations to secure or defeat legislation. It's collected by the legislative leaders, held until after adjournment, then divided among the participating lawmakers. Contributors to the Lorimer jackpot never have been specifically determined, but the names of the usual corporate suspects came in for speculation. Lorimer insisted to the end of his days that he knew nothing of the plot, although White quoted one participant as saying, "I made my deal with Lorimer direct." Neither John Hopkins nor Roger Sullivan was implicated in the bribery scheme. Most suspicion about the identity of the chief fundraiser focused on Chicago lumber magnate and timber lobbyist Edward Hines, a Republican activist and staunch Lorimer supporter who emphatically denied involvement.

After the legislature adjourned, White said he went to Browne and told him he really could use the first installment. The two stepped into a men's room in the state capitol where Browne slipped his colleague $100 "to help you for a few days." White collected another $900 from Browne in June in Chicago and received his jackpot share in St. Louis, conveniently just across the Mississippi from his East St. Louis office. He'd been notified by telegram on July 14 to meet state representative Robert Wilson of Chicago the following day at the Southern Hotel. There he saw Wilson, downstate representative Michael Link and a handful of other legislators. Everyone went up to Wilson's room, where they drank, smoked cigars and were individually called to the bathroom for the payoffs. Wilson explained that

Browne had taken ill, and he was standing in. Some of the conspirators complained of getting short-changed. Wilson said the gang didn't get as big a pot as they'd expected, but Browne would explain everything when he recovered. White said he didn't complain. "I took the $900 and put it in my purse and told Wilson I was satisfied." White wrote that he paid off all his debts and then went to Chicago for a short vacation.

Publication of Representative White's revelations caused an uproar in Washington. Official charges of corruption against Lorimer were predicted to come in short order and, if proven, could lead to a quick exit for the newly chosen senator. Less than a week after the story broke, State's Attorney Wayman obtained indictments against Browne, Wilson and Link. A county grand jury accused the minority leader of bribing White. Wilson and Link were indicted for perjury, the former for falsely testifying that he did not pay White and another lawmaker $900 each, the latter for denying he was present when the payments were made. Browne lost a bid to have his indictment quashed. After initially remaining silent, Lorimer took the offensive. He stood up in the Senate, proclaimed his innocence and denied that any member of the general assembly had been bribed to vote for him. Redundantly, he introduced a resolution calling for an investigation of the charges against him. A Senate committee was already planning to meet and discuss the framework of such an undertaking.

With the always contentious Democratic state convention and a particularly competitive mayoral primary on the horizon, the last thing Roger Sullivan needed was any identification with the Lorimer affair. Some two hundred downstate Democratic opponents weren't about to let him escape. They punctuated their displeasure with symbolism by meeting in Lawrence Stringer's hometown of Lincoln, about thirty miles north of Springfield. There they castigated Roger along with all the Democratic lawmakers who voted for Lorimer. Stringer himself pleaded a prior commitment but sent a letter of support. The attendees adopted a resolution repudiating the turncoats and vowed to defeat any who ran for reelection to the legislature. A delegate from Chicago named Raymond Robins recalled watching from the gallery as the seat got "put on the block and sold to a man whom nobody had desired...a man whose whole career has been that of public plunder against the interests of the whole people of this state." Next, Robins turned his guns on Sullivan. "Why was it," he asked, "that the Democratic Party was turned over to a bunch of thieves to be handled with 'jackpots' and to be sold out for a Republican?" One reason, he claimed, was that the party "has been largely in the control of one man [Sullivan] who gets his living and

has made himself rich at public franchises.…[H]e stands for those [office holders] who are faithful to the public service corporation that will plunder the people. He owns one of these [largely by] himself [Ogden Gas]. The money Sullivan made by overcharging for low-grade gas, Robins continued, he spent "in primaries and elections to corrupt the people." Anyone who wanted to get rid of Lee O'Neil Browne, he maintained, should start by getting rid of Roger Sullivan.

The fortunes of beleaguered Senator Lorimer seemed to skyrocket when a jury in Cook County acquitted House minority leader Browne of bribing Representative White to vote for Lorimer. After twenty-seven ballots and more than twenty-one hours of deliberations, the jury foreman said the panel simply didn't find White's story credible enough to send a man to the penitentiary. "[I]f that man White ever saw the jury," the foreman explained, "it was out of the corner of his eye. He could not sit on the stand and look one of us in the face.…I believe it was impossible…to ruin [someone] for life on the testimony of such a creature."

A jubilant Browne announced that he was returning to LaSalle County to resume his reelection campaign, even though he was facing yet another trial in Springfield the following month. An earlier trial in Chicago had ended in a hung jury. Representative Wilson, who had earned the sobriquet "Bathroom Bob" for his chosen payoff venue, still faced perjury charges in Chicago as well as conspiracy charges in Springfield. Their House colleague Michael Link was granted immunity after he confessed to committing perjury. Lorimer offered no public comment, but his attorney said his client was elated. Word of the Browne verdict came to the senator by hand-delivered note as he conducted a directors meeting at his LaSalle Street National Bank. Afterward, his top lieutenants arrived to offer congratulations, as if their leader also had been acquitted. The U.S. Senate would render the final verdict, but that process, which wouldn't conclude for two more years, was just beginning.

Six members of a Senate subcommittee, three from each party and all but one a lawyer, arrived in Chicago in mid-September 1910 to start their investigation. (Illness prevented a seventh member from making the trip.) Only one basic question demanded an answer: was Lorimer's election affected by bribery or corruption? Whether or not Charles White was a shifty-eyed scoundrel remained immaterial, as did any necessity to prove that Lorimer himself had paid off legislators. To expel the Blond Boss, members of the Senate needed only to convince themselves that bribery had swung the election. Lorimer had received 108 votes, 6 more than necessary. If more

Former President Teddy Roosevelt strongly supported William Lorimer's expulsion from the U.S. Senate. President William Howard Taft, who needed Lorimer's vote on key legislation, was ambivalent. *Courtesy of the Chicago Public Library.*

than 6 were found to be tainted, the case against him would prevail. On the surface, the task at hand didn't appear to be that complicated.

About this time, Lorimer's task of vindicating himself acquired an unforeseen complication when former president Teddy Roosevelt, out of office but still enormously popular, decided to become involved. The ex-president was to be honored at a dinner at the Hamilton Club in Chicago. When he learned that Senator Lorimer's name appeared on the guest list, Roosevelt loudly proclaimed that he would not attend and share a table

with such a notorious beneficiary of corruption. To ask him to do so was insulting, Teddy declared. The club withdrew Lorimer's invitation. The senator resigned from the club as quietly as possible, but the incident received national attention. Much of the press, biographer Tarr wrote, "approved of Roosevelt's self-righteous action."

One week apart in January 1911, the Senates of Illinois and the United States opened inquiries into the election of the Blond Boss. State lawmakers formed a committee to investigate "alleged acts of bribery and official misconduct" by members of the general assembly. The U.S. Senate approached its task from a somewhat different direction: determine whether or not Lorimer's election was tainted and, if so, decide on possible expulsion. In the words of the U.S. Senate keynoter, Senator Albert Beveridge of Indiana, the body needed to decide "whether [Lorimer's] senate seat was purchased or was just hung on the Christmas tree by old Santa." Lorimer appeared nonplussed, even defiant. He refused to testify before the committee and announced that he would remain on the chamber floor while his colleagues debated his fate. He also continued to vote. The day before his case was scheduled for a final decision, he joined the majority in defeating a resolution providing for the direct popular election of senators.

On March 1, 1911, the U.S. Senate astonished the political world by voting 56–40 to retain Lorimer. With packed galleries looking on, ten Democrats joined thirty-six Republicans in support of the Blond Boss, while twenty-two Republicans and eighteen Democrats voted to oust him. The result generated almost universal outrage from the national press. The *New York Globe*'s reaction typified the outcry: "[T]he whole body is besmirched and bemired." President Taft found himself in an awkward position. During the run-up to Lorimer's election, the president had rather clumsily but strongly signaled his approval from behind the scenes. In his pro-Lorimer lobbying efforts, lumber magnate Edward Hines intimated that he was conveying the president's wishes. Taft wanted to add a senator who would line up with the Old Guard, particularly in support of his tariff legislation. As the evidence against Lorimer piled up, the president underwent a conversion of convenience and demanded his putative designee's ouster. So too did Teddy Roosevelt, other national Republican leaders and the press. "The whole thing began when I refused to dine with him at the Hamilton Club," Roosevelt crowed.

In the face of such opposition, how did Lorimer prevail? His biographer offers the following explanation:

The bitter divisions within the Republican Party between the progressives and the Old Guard, the concern of Republican and Democratic traditionalists for senate precedent, and the personal influence of l [Democratic senator] *Bailey* [of Texas] *were all important factors. The Old Guard saw the Lorimer case as a further insurgent onslaught upon the senate establishment; its members believed the case a test of their ability to maintain control.*

Tarr further sensed a backlash against the press and its ongoing attacks against alleged senatorial corruption and ethics lapses. Whatever the reasons, the Blond Boss had won—for now.

6

EXPELLED!

Fresh disclosures before the Illinois Senate committee investigating Lorimer's election led the U.S. Senate to reopen its probe. For two days in July 1911, Governor Deneen gave the U.S. Senate panel and the nation an education in how the game is played in Illinois. Roger Sullivan followed Deneen to the witness chair two months later but would prove infinitely less forthcoming, not to mention interesting.

During his lengthy testimony, the governor comes across as cooperative and straightforward. A certain matter-of-factness—"well, that's just how it goes"—pervaded his exchanges with the senators as he attempted to explain how he was beset by connivers in both parties. If, as sometimes suggested, a man can be judged by the enemies he makes, Deneen could have been acclaimed a hero by opponents of big business and machine politics. He recounted how Sullivan and Lorimer joined forces against him in the 1908 election. They were aided, he said, by a coalition whose varied interests he had opposed at one time or another. He identified the conspirators as the Burlington and Illinois Central Railroads, the liquor industry, electric and gas utilities and federal officeholders. The liquor and utility forces, he said, joined with the Pullman Company, the Chicago Union Stock Yards and grain elevator operators to raise a $400,000 war chest to defeat him. Deneen revealed that following his election, Lorimer and Illinois's House Speaker Shurtleff, another Republican elected with the help of Democratic votes, indicated that they still could oust the governor by employing arbitrary rulings in connection with the official canvass. That disclosure mystified Senator William Kenyon of Iowa.

Kenyon: "*Did they have power to settle whether or not you should be governor of Illinois after you had been chosen by the people?*"

Deneen: "*I had heard they had discussed whether or not Mr. Shurtleff would have the power in the canvassing board to declare Mr. Stevenson elected regardless of the returns.*"

Kenyon: "*So that, in the long run, you considered that Senator Lorimer would determine whether or not you should be governor of Illinois?*"

Deneen: "*I assumed he would direct the course of matters finally, yes.*"

Kenyon: "*Is your system of politics such in Illinois that one man can oust a person who has been chosen governor by the people?*"

Deneen: "*They had plenty* [of votes] *if they cared to do it by the force of numbers....That was my judgment at the time, and it is now.*"

Instead of following that course, the governor stated, Lorimer pursued his unsuccessful strategy of getting him to resign and going for the Senate seat.

When Roger's turn came, he presented a much more difficult study. Trying to pin him down, the Senate committee discovered, was like trying to land a glove on a cagey veteran boxer. Sullivan strained credulity on a few occasions, such as when he testified that he couldn't control the vote of the state representative from his home district. He insisted that he specifically told the man to vote for Lawrence Stringer, but the lawmaker defied him and voted for Lorimer. At another juncture, Sullivan denied that he and the Blond Boss "ever worked together in politics and were, in fact, enemies." He did concede that Lorimer was someone who would do a favor without regard to the person's political affiliation. Senator Wesley Jones of Washington, a lawyer who should have known how to better frame a question, tried to zero in on whether Sullivan and Lorimer worked together to elect Adlai Stevenson. The senator asked whether "anybody appeared before your executive committee" to arrange support for Stevenson. Roger batted that one out of the park. "Nobody," he answered. Of course not. The deal could have gone down on the street, over dinner or one hundred other places.

Little more than a year after voting to retain Lorimer, the full Senate prepared to revisit the question. The hearings over, the investigating committee received a 114-page brief from Lorimer's attorney, Elbridge Henecy, the losing 1901 mayoral candidate supported by Hopkins, Sullivan and the Blond Boss but defeated by Harrison. Henecy argued that the Senate should dismiss the case for lack of new evidence; the confessions of Charles White and others should be disqualified on grounds of perjury. On March 28, 1912, the committee voted five to

three that the new evidence did not justify reopening the case. Majority and minority members filed reports with the full Senate, the losing side contending that fifteen Illinois legislators had been bribed to vote for Lorimer, even though the Blond Boss himself didn't participate in the plot. The minority report further found lumberman Edward Hines an accessory to corruption.

The committee vote produced a national uproar over an alleged second whitewash. Newspapers everywhere renewed their calls for Lorimer's resignation or dismissal. Washington State's Jones came in for especially harsh criticism for siding with Lorimer after voting a year earlier to expel him. At the beginning of June, Lorimer made clear that he had no intention of resigning, and on June 4, Senator John Kern of Indiana, principal author of the minority report, led off debate for round two. With both parties' presidential nominations up for grabs and the national conventions fast approaching, June and July 1912 would prove as remarkable a two-month period as any in recent political annals.

Before laying out the case against Lorimer, Kern confessed that he found it "an unpleasant duty to inflict pain [on] a genial and kindly man." Then, over four days, he hammered away as Lorimer occasionally interrupted with nettlesome questions. Kern posited that the "stand pat leaders of the Republican Party," obviously including President Taft, desperately wanted to add another Senate vote in favor of high protective tariff legislation. According to Kern, these men deputized Hines, who raised the cash used to bribe legislators to support Lorimer. The Indiana lawmaker recalled the testimony of former Illinois governor Yates, who had told of a 1903 incident involving the Speaker of the House, a case Kern described as "really pathetic." Yates said the Speaker had told him he'd been offered a $200,000 bribe to move a "notorious" piece of legislation. Governor Yates advised him to expose the offer. After the Speaker followed the counsel, the legislature put the man himself on trial and censured him for offending the dignity of the House. Shamed, he went home and died not long afterward. Lorimer interrupted to ask whether Kern was aware that Governor Deneen and the Chicago newspapers "now prosecuting this case were the men who prosecuted the speaker and drove him to his grave." If Lorimer spoke truthfully, Kern observed, it only accentuated his point that conditions in Springfield were so disgraceful that they "shocked the conscience of every man who cares anything about the country or its institutions." It was this system in which Lorimer played a part that deserved the condemnation of the U.S. Senate, Kern concluded.

When Kern concluded his four days of oration, the Senate put aside the Lorimer matter until July 6 to allow for the parties to hold their conventions and write the second chapter of that remarkable late spring, early summer. The Democrats made the short journey up the road to Baltimore, while the Republicans headed for Chicago.

Roger Sullivan led the Illinois delegation to the city that Hinky Dink Kenna called the hottest place in which he'd ever dipped his toe. The Illinoisans found the old Monumental City on Chesapeake Bay in the throes of a heat wave, bedecked with flags and bunting, awash in lights, with throngs filling the streets. Souvenir hawkers appeared everywhere. Crowds filled the lobbies of hotels whose last available rooms had been snapped up long ago. Sullivan arrived in complete control of the party machinery, having routed the Harrison faction at the county and state levels. In party balloting prior to the big show in Baltimore, Roger's regulars placed twenty of their people in the twenty-five seats on the state central committee. Nevertheless, the mayor arrived in Baltimore, primed for a credentials challenge, at the head of a three-hundred-member following. John Hopkins showed up too, just to watch the fight, he said.

In a roll call of states, the Sullivan forces turned back Harrison's bid to supplant them by a four-to-one margin. Every Sullivan delegate won a seat. "We have whipped them at every stage of the game," Roger boasted. A dejected mayor returned to Chicago. So, too, did former mayor Hopkins. "Just as long as Carter doesn't get a delegate badge, I am satisfied," said Johnny.

As late June became early July, it appeared that no one would claim the grand prize. Days and nights of balloting produced only deadlock as fourteen thousand sweltering delegates and spectators waited in vain for a break. Coatless men and women in summer finery presented a sea of white, the stale air broken only by people vigorously fanning themselves. Each ballot brought a hush of expectancy, followed by more frustration. House Speaker Champ Clark of Missouri maintained a significant early lead but couldn't reach the necessary two-thirds majority. One ballot after another, Sullivan kept all fifty-eight Illinois votes in the Clark column, but poker master Roger had yet to play his hole card.

When Speaker Clark arrived on the scene, he was confronted by the news that his pickup of all ninety New York votes had been more than offset by defections of other states that caused him to lose overall support in the face of an advance by Woodrow Wilson, governor of New Jersey. Clark sought out Roger Sullivan. George Brennan, Sullivan's top deputy, quoted the Speaker

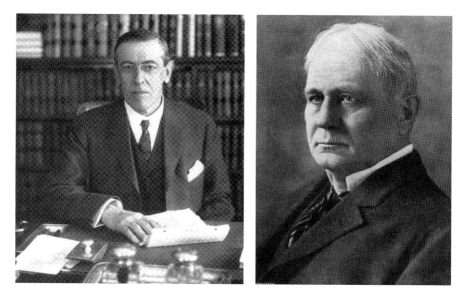

Left: Sullivan's late switch to Wilson was considered pivotal. Two years later, when Sullivan ran for the U.S. Senate, Wilson did virtually nothing to help. *Courtesy of the Chicago Public Library.*

Right: U.S. House Speaker Champ Clark of Missouri enjoyed Roger Sullivan's early support for president in 1912 but stepped aside as momentum turned to Woodrow Wilson. *Courtesy of the Chicago Public Library.*

as saying, "Mr. Sullivan, I am very grateful to you for the manner in which the Illinois delegation has voted for me. But I realize my case is hopeless. You are released from all further obligation to me." Regardless, Sullivan stood by Clark for two more ballots. Then he realized the psychological moment had arrived. "All that time," Brennan said, "[Wilson manager] William McCombs was begging and pleading with Roger to switch....McCombs was on Roger's heels morning, noon and night, almost with tears in his eyes, seeking the Illinois delegation." McCombs agreed that the Wilson camp was in distress. "There were Wilson delegations in that convention that were wavering in their support. There were delegations that I know absolutely were going to leave him and go to another candidate....Mr. Sullivan knew the perils of the situation...knew that he could turn to another candidate and defeat Mr. Wilson." Roger held 'em close to the vest, keeping McCombs and everyone else in suspense. Turning to someone other than Clark or Wilson never crossed his mind.

As the fortieth ballot approached on July 2, the logjam appeared ready to break. When Sullivan arrived at the convention hall, he learned that if

Illinois would go for Wilson, Alabama, Maryland, Virginia, Washington and West Virginia would follow. That was all he needed to hear. George Brennan said that Roger leaned over to New York leader Charles Murphy and exclaimed, "This is the time for me to go, Charley. Illinois switches to Wilson." When Illinois's turn came, Sullivan stood and said, "Illinois casts 58 votes for Woodrow Wilson." The convention erupted, and the promised chain reaction of states followed. Thomas Woodrow Wilson, idealistic former university president and neophyte politician, became the Democratic nominee for president of the United States.

The heat wave that engulfed Baltimore extended to Washington and the halls of Congress where the Senate renewed debate on the future of Billy Lorimer. Pro- and anti-Lorimer orators took turns speaking to a chamber significantly depleted of colleagues who sought relief from the steam bath where they could find it. Biographer Tarr speculated that many may have made up their minds, so why hang around and perspire? Lorimer remained in his seat, determined to hear everything said about him. The final word—actually thousands upon thousands of them—fell to the usually taciturn senator. For fourteen hours over three days he pleaded his case, heaping scorn on Taft, Roosevelt and what he labeled the "trust press" for concocting a gigantic conspiracy against him. The president, he charged, was repaying his support by encouraging his fellow members to vote against him. Roosevelt had attempted to gain the presidential nomination through bribery, he alleged. The *Tribune, Daily News* and *Record-Herald*, he said, were guilty of stealing hundreds of thousands of dollars from taxpayers and schoolchildren by cheating on their taxes. *Daily News* publisher Victor Lawson stood accused of hypocrisy and theft, someone who dodged taxes on his home and newspaper. Lorimer colleagues who spearheaded the reopening of the inquiry had "humbugged" the Senate through a "shameless performance." You could be next, Billy warned his colleagues. "The guillotine" awaited those who refused to kneel before the "trust press."

On judgment day, with Lorimer's wife and other family members looking on from now-packed galleries, the Senate voted 55–28 to expel him. Twenty-six Republicans and twenty-nine Democrats formed the majority. Twenty Republicans and eight Democrats voted for retention. Against a backdrop of sobs and gasps, William Lorimer became the only senator ever ousted from the body because of an election influenced by bribery and corruption. Dozens of well-wishers pushed forward to shake his hand and offer sympathy. The *Tribune*, which had set the process in motion two years earlier with the publication of state representative White's story, proudly

proclaimed, "The great fight for civic decency and against corruption… has triumphed." Tarr wasn't so sure. "The irony of Lorimer's expulsion," he wrote, "is that a crusade supposedly devoted to honest and responsible government claimed a victim in a case where there was no evidence he had broken the law. But Lorimer had become a symbol to his most avid Senate antagonists, and in ejecting him they struck at boss politics, immigrant-based political machines, the liquor evil, and legislative corruption. Their vision of American society had no room for these elements."

Author Frederick U. Adams found another "victim" in Lorimer's alleged bag man, Chicago lumber executive Edward Hines. No one disputed the fact that Hines was a friend and supporter of Lorimer who lobbied on his behalf and acted as President Taft's unofficial emissary. Adams accepted Hines's emphatic denial that he raised $100,000 from the latter's business contacts to buy votes for Lorimer then "haunted his clubs, visited saloons, stopped friends and strangers in hotels and on the street and boasted that he had bribed the Illinois legislature," charges reported by the *Record-Herald*. Adams added that Hines "was described as a drinker of whiskey…with the inference that his alleged boasting was caused by excessive indulgence in liquor with low companions.…Never in his life has he drank whiskey in a saloon or anywhere else."

Adams maintains that Hines was targeted by the International Harvester Company and the *Tribune*, both owned by members of the McCormick family, because he and Lorimer had helped defeat separate pieces of legislation that each company wanted passed. The bag man story, Adams insists, was floated by a lone Harvester executive and fed to the *Record-Herald*, whose resulting editorial generated broader newspaper coverage that seemed to feed upon itself. When pressed by an Illinois Senate committee, neither the Harvester official nor the *Record-Herald* editor could claim any direct knowledge of Hines's alleged words or actions.

Lorimer, meanwhile, returned home to a hero's welcome organized by two up-and-coming members of his machine: William "Big Bill" Thompson and Fred Lundin, the self-described "Poor Swede." A car caravan accompanied the defrocked senator from Union Station to Orchestra Hall, where the cheers of 2,500 supporters supplied the music. Lorimer was hailed by a black Protestant minister, a white Catholic priest and Thompson, who introduced him as "a martyr." Draped in an American flag, Lorimer delivered a condensed version of his Senate speech, punctuated by blasts at the "trust press" and a promise to tour the state and tell the truth about his ordeal. The audience approved a

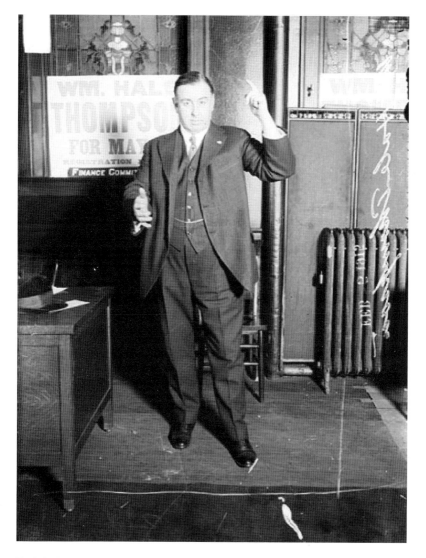

Early in his career, flamboyant three-term Chicago mayor "Big Bill" Thompson embraced his onetime sponsor Billy Lorimer after the Blond Boss was expelled from the senate. *Courtesy of the Chicago Public Library.*

resolution praising him as the embodiment of "the hope and future of the nation." The ex-senator never did make the promised tour.

Having steered the presidential nomination to Woodrow Wilson, Roger Sullivan made good on a longstanding goal: he stepped aside as Democratic national committeeman. He would remain the primary force in state party

politics but unburdened by official responsibilities. All in all, it was a good time to be Roger C. Sullivan. He'd played a vital role in nominating and electing his personal favorite for president and now stood ready to help dispense lucrative federal patronage jobs in Illinois. All Cook County offices and the governorship belonged to the party. True, he and Governor Edward Dunne had their differences, but the men were by no means enemies. In Chicago, Carter Harrison was showing signs of losing his touch, at long last. Perhaps the time had come, Sullivan thought, to carve out a new role for himself, a move to seriously consider when he and Dapper Johnny embarked on another of their international sojourns.

The Hopkins-Sullivan grand tour lasted exactly four months. They were accompanied by Helen Sullivan and daughter Virginia; Hopkins's sister Adelia; Father Edward Kelly, chaplain of the Seventh Regiment, Illinois National Guard and a previous travel companion; and Father James Callahan of St. Malachy's Church, Roger's and Helen's West Side parish. Their itineraries seemed odd to say the least. The men headed for South America, stopping in Brazil, Uruguay and Argentina, while the women went directly to Europe. Later, the Hopkins and Sullivan families reunited in France before splitting up again. Accounts of the journey make no further mention of the two priests, so it's possible they returned home from South America.

In London, Johnny and Roger, by accident or prearrangement, met up with George Ade, the famed Indiana humorist, who had spent the early summer in France. It's not clear how the three became acquainted. All being Chicago celebrities, it's possible their paths had crossed back home. The gregarious Hopkins, active in several social clubs and quick to make friends, perhaps discovered a kindred spirit. Like Hopkins, Ade was a lifelong bachelor who showed exceptional devotion to his father and mother. The Indiana writer also was a loving uncle, just as Johnny doted on his sisters. Whatever brought them together, the trio set out on an extensive tour of Russia, Poland and Germany, visiting Moscow, St. Petersburg, Warsaw and Berlin, among other destinations.

Any discussions about his political future that Roger held with Johnny or Helen, on shipboard or in foreign locales, can only be imagined. That the following year, 1914, would mark the first popular election of U.S. senators was lost on no one in politics, particularly Roger Sullivan. The Seventeenth Amendment had been ratified only three weeks before the Hopkins-Sullivan party set sail. Roger had his eye on the seat held by Republican Lawrence Y. Sherman, a veteran of Springfield's byzantine ways whose

term was expiring. It seems unlikely that either Helen or Johnny offered any discouragement, because after Sullivan lumbered down the *Lusitania*'s gangplank in New York Harbor, he hit the ground running.

Roger stepped back into the game unlike a man who had been away for four months. Conveniently, it seemed as though the game had awaited his return. Doors within the Wilson administration opened wide, and Sullivan entered—to engage in conversations with the treasury secretary and postmaster general to discuss appointments. He also met with the attorney general and the president's personal secretary, Big Joe Tumulty, to hash out appointments of U.S. attorneys. Obvious to capital insiders was the fact that this plain, beefy Chicagoan was a serious man to be treated with respect—someone who seemed to be getting most of what he wanted within a very short time.

Sullivan wouldn't make it official until early the next year, but he continued to send signals during the remaining three months of 1913. Immediately after his round of talks with Wilson cabinet members, he went to New York to close out the last links of his highly profitable yet still controversial association with Ogden Gas. There, with a recently retired chairman of Peoples Gas, he worked out the terms of the sale to Peoples of his remaining shares in Ogden and Cosmopolitan Electric. The transaction offered a sure sign that he was preparing to run. Opponents were certain to resurrect the old controversies, but ending all ties to the companies would make his defense a lot easier.

"From now on you will have to refer to me as a plain biscuit manufacturer," Sullivan told reporters on his return to Chicago. "By the end of the week, I will have disposed of every bit of stock I own in corporations. When next you call, you may find the Ogden Gas Company and Cosmopolitan Electric Company signs erased from my office door."

He made it official in early 1914. Opposition quickly formed within his own party. In early February, some two hundred anti-Sullivan Democrats gathered for an evening of Roger bashing at the party's Springfield temple, the St. Nicholas Hotel. They heard one of four initial challengers rip Sullivan for a list of alleged misdeeds going back nearly twenty years, including his support of the Allen Bill, Lorimer's election and, indirectly, Ogden Gas.

"I am not opposed to Mr. Sullivan because he is a millionaire," state lawmaker Frank Comerford declared. "I am opposed to the way he got the money.…I distinguish between the man who earns his money in legitimate business and the politician who collects millions." Comerford branded Sullivan a political boss, not that the charge hadn't been leveled as often as

Catherine O'Leary's cow had been blamed for starting the Chicago Fire. Roger was "a walking delegate of big business" who needed to go.

Sullivan's most formidable adversary wasn't in the banquet hall. Secretary of State William Jennings Bryan, who loathed Sullivan and once called him a "train robber," fired the opening salvo in what would become a continuing vendetta to deny him the nomination. Bryan characterized Roger as the "William Lorimer of Illinois Democracy" in his newspaper the *Commoner*, which he continued to publish out of Lincoln, Nebraska, long after he'd assumed the highest position in President Wilson's cabinet. Why Wilson allowed this apparent conflict of interest, not to mention why he allowed Bryan to meddle in domestic politics and attack the man who helped him win the presidential nomination, raised interesting questions. Sullivan had to wonder about the man he'd helped put over the top. All-out support for Wilson's policies now formed the foundation of his Senate campaign.

"It was unthinkable," Bryan railed, that Roger be elected. "If he had any conception of the dignity of [the] office…he would not aspire to the place." Sullivan issued a written statement that said, "If a Democrat in Illinois has no right to announce himself as a candidate in his home state without the sanction of Mr. Bryan…then my candidacy is 'unthinkable,' not otherwise." When Bryan was running for president, Sullivan recalled, he, Roger, was of sufficient importance to help him. "[H]e willingly permitted me to finance the campaign in his behalf, and he tendered me his grateful thanks for my efforts."

President Wilson opted to remain neutral in the Illinois primary and didn't stop Bryan from publishing a second and third editorial in his paper, denouncing Sullivan in ever more florid terms. Where did the president stand, anyway, Sullivan backers wondered? If his professed neutrality were genuine, why didn't he tell his chief diplomat to shut up? If he favored Roger, as many believed, why didn't he say so rather than let a cabinet officer publicly contradict him on a matter of political policy?

Bryan and his newspaper, while they exerted some influence in rural precincts, could largely be ignored closer to home. More significant developments were happening in the so-called river wards, where close elections were often decided. After years of performing his high wire act, Carter Harrison was beginning to lose his balance. He drove Kenna and Coughlin into the Sullivan camp by ordering a crackdown on their Levee District then stood by as a judge beholden to the mayor began a purge of the First Ward's notoriously inflated voter rolls. Harrison delivered the final

insult when he ordered the Hink and the Bath to support the offending judge in the upcoming election. Sullivan welcomed the pair with open arms. With their help, Roger captured the nomination over Congressman Lawrence Stringer, the man Sullivan apparently sold out for Billy Lorimer in the battle for the U.S. Senate seat. That Stringer had enjoyed the support of Bryan and Harrison, along with Governor Dunne and U.S. senator J. Hamilton Lewis, made Roger's victory that much sweeter. He now prepared to face off against the Republican incumbent, Lawrence Y. Sherman, in November.

The elephant in the room had remained fairly unobtrusive during the primary, at least as unobtrusive as an elephant can make itself. It stepped forward to be recognized in the less-than-two-month general election campaign, a span so short as to seem quaint—some would say refreshing—by latter-day measurements. Anti-Catholicism dogged Sullivan in a number of downstate counties. Roger didn't refer to the experience publicly until after the election, but he felt its presence.

Opponents circulated an anti-Irish, anti-Catholic scandal sheet called *The Menace*. Thousands of placards appeared: "Roger Sullivan Is a Catholic. Be a True American. Vote Against the Pope." The source wasn't identified. A copy of the placard found its way into Carter Harrison's voluminous clipping file. On it appears an undated notation in Harrison's handwriting that claims: "And it was paid for by the Sullivan gang," suggesting that Roger sought to energize Catholic voters and gain sympathy from the general electorate by portraying himself as a victim of religious bigotry. Whatever the source, anti-Catholicism did exist in parts of southern Illinois in 1914, and Sullivan believed he was being targeted.

The Sullivan campaign strategy couldn't have been more straightforward—run as an unabashed supporter of President Wilson and everything he stood for. Roger stated the theme in an op-ed piece: "[S]upport the peace policy of the President of the United States and thereby aid him to readjust economic conditions so that, in the event of a long continued European war, we can remain upon a sound financial basis…" He claimed that Republican Sherman was "not in sympathy" with Wilson's policies. In the same article, Sullivan confronted the two most persistent arguments against his candidacy: political bossism and Ogden Gas:

The only persons who designate me as a political boss…are persons who have come from distant states [read Bryan] *to advocate the* [third

party] *candidacy of Mr. [Raymond] Robins....I have been one of many leaders of the Democratic Party in Chicago and Illinois....I have aided and assisted the election to office of the best men whom the Democrats have put forward....If that constitutes a boss, then I have been one.*

The only thing Ogden Gas ever did to the public, he argued, was permanently lower rates and pay a percentage of its gross receipts to the city.

As the clock ticked down to the November 3 election, the silence emanating from the White House became deafening. It seemed one thing for the president to remain neutral in a party primary, quite another to stand on the sidelines while the primary winner was running on an all-out, pro-Wilson platform. At the eleventh hour, two Wilson surrogates stepped forward. Postmaster General A.S. Burleson, addressing an audience of 1,200 in Peoria a week before the balloting, declared, "If you want to help Woodrow Wilson...vote for Roger C. Sullivan for United States Senator....The eyes of Europe are turned toward the President as the ultimate arbiter of the terrible war. Will you repudiate him? Or will you support him?" Democratic national chairman William McCombs, Wilson's 1912 strategist, picked up the baton in Chicago three days before the showdown, reminding a North Side audience that the president owed his nomination to Roger Sullivan. McCombs called Sullivan "an able, big-brained man," a national leader who never broke his word, a supporter of Wilson from the beginning. Yet no words came from the president himself. The White House made clear that the postmaster general's endorsement amounted to the final declaration. Wilson would not write an endorsement letter, as he had on behalf of other Democratic Senate candidates.

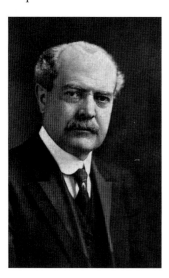

Democratic governor Edward Dunne of Illinois acted much like President Wilson and did nothing to aid Sullivan's Senate campaign. Their indifference, combined with Bryan's opposition, proved costly factors in Sullivan's narrow defeat. *Courtesy of the Chicago Public Library.*

Sullivan genuinely believed he would win, but his ancient enemies had other ideas. Harrison agreed to support the entire ticket, made a few half-hearted speeches, then quit campaigning. Bryan's downstate

followers went all out to defeat their party's Senate nominee in counties that normally went Democratic. Governor Dunne waited until the end to endorse Sullivan but did nothing else on his behalf. In the final analysis, this tepid support or flat-out opposition by prominent Democrats hamstrung Sullivan's efforts to overcome Sherman's downstate popularity. He lost by just under fifteen thousand votes statewide. Roger expressed "few regrets" and "deep disappointment," then went on to regret that "we have people so minded to penalize a man for the religion he got from his mother, and that we have men willing to capitalize [on] this baseness for the sake of getting office. This appeal to religious prejudice, particularly when given countenance by high personages in Democratic officialdom [read Bryan], is still effective in some parts of Illinois." Bryan declined to comment. Vice President Thomas ("What this country needs is a really good five-cent cigar") Marshall, who was passing through Chicago, also had nothing to say about the election. He confined his comments to an outbreak of hoof-and-mouth disease at the stockyards.

Overshadowed by the first popular election of a U.S. senator, the campaign for the 1915 mayoral election was taking shape. In August 1914, on the hottest day of the year, Billy Lorimer surfaced at his annual picnic to endorse a loyal member of his organization, William Hale "Big Bill" Thompson. To some, an embrace by Lorimer might have been likened to the kiss of death. Not only had Lorimer been expelled from the Senate, he now found himself facing indictment for embezzlement in connection with the state-ordered closing of his LaSalle Street Bank as well. "I have stood up for your rights," the Blond Boss told the perspiring throng, "and I have been unfairly punished by vicious men. I promise you that I will never stop fighting. And to help me in the fight, I bring to you a good friend of all, a loyal American, a man who knows how to fight and never quits—William Hale Thompson, the next Mayor of Chicago."

Big Bill gladly accepted the embrace. Freely perspiring, like everyone else, Thompson borrowed a page from his host to declare, "If I become a candidate for mayor, it will be to fight the crooked 'trust press' that has tried to ruin the name of an honorable man and will go on to ruin all unless it is stopped." The crowd cheered, the band played and people flocked to registration booths to sign pledges of support for the millionaire yachtsman, ex-football star and former ranch hand.

Lorimer's LaSalle Street Trust and Savings Bank and three others he owned with partner Charles Munday had closed their doors on June 12, 1914, sparking rumors of imminent indictments. But the closings came

as no surprise, given the institutions' jinxed beginning and subsequent checkered life.

LaSalle Street Trust began life in 1910 as a national bank but was forced to give up its federal charter two years later in the face of highly critical reports by government examiners. It then continued to operate as a state bank. Days after its first incarnation, the bank had to deal with the backlash from the initial charges surrounding Lorimer's election to the Senate. As the allegations intensified, a serious run on deposits ensued. At the time of its failure, public funds accounted for 26 percent of LaSalle's deposits. Biographer Tarr said politicians received loans "on poor security, possibly in return for securing public funds."

A federal grand jury indicted Lorimer, Munday and three other bank officers in August 1914, but the thirty-six-count indictment wasn't returned in open court until early October. The charges centered on six specific instances of misapplication of funds and conspiracy to defraud. Many believed that Munday, not Lorimer, was the true culprit. "The downstate businessman made unsecured loans to his own enterprises, 'kited' funds to his Southern Illinois banks and lied to national bank examiners," Tarr maintained. Billy, his friends believed, was just being Billy, lending money to people who needed it regardless of their ability to pay it back. "When the bank opened," Lorimer said, "I don't believe five percent of the depositors were not my warm personal friends."

Lorimer and Munday didn't stand trial until March 1916. As he did in the Senate proceedings, Billy claimed to be the victim of a conspiracy. In this instance, that argument, or some other line of defense, prevailed. The jury acquitted him but convicted Munday, who served a brief term in prison.

7

PATRIOTS

The day Billy Lorimer was acquitted of bank fraud, another banker and old friend of Roger Sullivan was carried by pallbearers from his home at 3340 West Washington Boulevard for the trip to the cemetery. The death of Andrew Graham, Roger's handpicked though unsuccessful candidate for mayor in 1911, marked the beginning of another sad postscript to the Ogden Gas affair, which Sullivan never seemed able to put behind him. Affectionately known as the "Big Brother of the West Side," Graham died in May 1916 at age fifty-four. Two sons, Ralph and Frank, took over operation of Graham & Sons Bank on West Madison Street. Depositors in the working-class neighborhood loved the bank as they had Andy, who used to say, "I would rather lend $1,000 to 100 little fellows than $1 million to the richest men in the world." His charity to those down on their luck was legendary. Unknown to the public was that the uninsured institution had been in trouble for at least fifteen years. Some speculated that the deteriorating condition hastened Andrew Graham's death.

The bank's heaviest obligation was a $2 million loan from the Continental and Commercial National Bank. Graham & Sons had reduced the debt to $700,000 by June 1917, but after five years and repeated failures to obtain a satisfactory accounting of the bank's health, Continental called in the loan. Finally, the Graham brothers did produce a financial statement; it showed their institution to be insolvent. Continental president George Reynolds sent for Ralph Graham and told him he was very sorry but insisted on immediate payment. Ralph Graham asked for more time and said he was certain

Roger Sullivan would help. "I had already sent for Mr. Sullivan," Reynolds explained later, "and when he came I told him it would take $6 million [to restore solvency]. He said that was too big an obligation to assume for the sake of friendship. I then took the steps to close the bank."

On June 29, 1917, the U.S. District Court seized Graham & Sons, ordered its doors closed and appointed a receiver. Some twenty-seven thousand customers, many elderly, poor, ill or all three, had about $4 million on deposit. Throngs gathered outside the locked doors, not believing what they were witnessing. Some wept. Others became hysterical. "Andy Graham's bank? Andy had a smile for every man and woman, and there was confidence in his handshake. We loved him and trusted him."

The matter dragged on for nearly three years. State's attorney Malachy Hoyne obtained indictments against Ralph and Frank Graham for allegedly accepting deposits after they knew the bank was insolvent. At their trial, Ralph testified about his meeting with Continental president Reynolds.

I told him I would try and get Roger Sullivan [to help] because my father and Mr. Sullivan had been friends for a great many years....[My] father financed the Ogden Gas deal for Mr. Sullivan, and that was a very successful venture....Frank went in search of Mr. Sullivan. Frank called me up and said that the clearing house checks were in and that we would have to [pay them]. I called the clearing house and asked for a few moments' time. Then Frank called me again and said that Mr. Sullivan would do nothing.

The Graham Bank story had an ending straight out of Hollywood. Shortly before his death, Andrew Graham invested $6,000 with a man named Saul Ginsberg, who had a dream of manufacturing ventilated mattresses. Ginsberg had been turned down by other banks. Graham admired the man's pluck, didn't bother to enter the investment in his books and largely forgot about the matter. Ginsberg formed the Marshall Ventilated Mattress Company. The firm thrived. It opened and expanded a manufacturing plant at 14th and Morgan Streets on the near West Side. Sometime after Andy Graham died and the bank failed, Ginsberg presented the Graham family with nearly one thousand shares of Marshall stock as a return on investment. During court proceedings, the family maintained that the stock represented a gift to Graham's widow and other family members. Attorneys for the creditors argued that since the bank, not the family, had financed the venture, the stock belonged to the creditors. Under the terms of a compromise settlement

in May 1920, three years after the bank failure, the Grahams agreed to turn over the stock. The shares were worth $1.5 million, a 250-fold return on Andy's investment. The funds supplemented the bank's assets of $3.1 million, more than enough to offset $4.2 million in liabilities and assure creditors of receiving 100 cents on the dollar.

In death, Andy Graham proved to be one very astute—or more likely very lucky—investor. His onetime friend and political sponsor never commented publicly on the Graham Bank's troubles.

America's entry into World War I on April 6, 1917, set the stage for an unlikely reunion of some of the players in the Ogden Gas and Cosmopolitan Electric franchise intrigues more than two decades earlier. President Wilson called on the governors of each state to create civilian councils of defense that

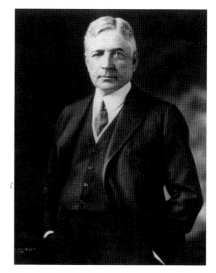

Illinois Republican governor Frank Lowden, George Pullman's son-in-law, appointed Hopkins, Sullivan and former Ogden Gas attorney Levi Mayer to the Illinois State Council of Defense, a prestigious World War I homefront organization. *Courtesy of the Chicago Public Library.*

would work under a national board to coordinate a variety of activities in support of the war effort. Republican governor Frank Lowden, with the unanimous approval of the legislature, set the Illinois State Council of Defense in motion. He named Commonwealth Edison president Sam Insull chairman of the fifteen-man, one-woman body. The choice required a bit of backbone. Insull's selection raised the eyebrows of newspaper columnist Carl Sandburg and others who already considered Lowden too close to the utility and traction crowds. A decade earlier, Lowden and Insull had served together on the National Business League. Though a naturalized U.S. citizen, the British-born Insull retained a fierce loyalty to the Crown and had been itching for just such an opportunity to aid the Allied cause. Only Wilson's strict neutrality policy and a desire not to offend his German American and Irish American customers had prevented Insull from seeking some type of involvement sooner.

The Ogden-Cosmopolitan connection crystallized when Lowden named to the bipartisan council a trio of Democrats whose appointment to any blue-ribbon civic committee would have shocked the community twenty

years earlier. Enter none other than John Hopkins and Roger Sullivan, accompanied by Levi Mayer, former attorney for Ogden as well as Charles Tyson Yerkes. Of all the members of the Illinois bar, Lowden chose Mayer as the representative of the legal community. Hopkins was named secretary. The irony of the Hopkins-Sullivan appointments appeared twofold: when Johnny ran for mayor, Lowden condemned him for consorting with "Frenchy the Gambler, Kid Harris, Big Ed Hennessey and the honorable Hinky Dink." That Hopkins and Sullivan had tried to fleece the defense council's chairman added to the subplot. That was then. Insull, Hopkins and Sullivan had settled their differences long ago and become close personal friends. Now, Roger and the governor were becoming pals, so Sullivan's appointment to a prestigious commission might not have been as surprising as it seemed. Hopkins and Mayer, on the other hand, had been going about their respective businesses in relative obscurity. It's possible that Lowden brought them on board at Sullivan's urging.

Dealt this hand, three men who had seen themselves castigated as poster boys for corrupt politics embraced the opportunity to reorder their legacies. They could cap their careers as patriots of the first degree. Service on the council could transform Hopkins, the Ogden Gas mayor; Sullivan, his co-conspirator and classic political boss; and Mayer, their legal enabler, into civilian wartime leaders, if not actual heroes. Their selections raised not the slightest criticism from press or public.

Initially, President Wilson envisioned the state councils as crypto-spy organizations to keep an eye out for seditious activities, particularly among German Americans. Insull had other ideas. Aside from frowning on the negativism, he saw opportunity for innumerable positive measures. He turned the council into a finely tuned, multifaceted homefront war machine driven in part by a couple of men who knew a thing or three about crafting and running machines. The team's overarching goal was to make every citizen of Illinois feel that he or she was performing a patriotic service.

The council proved to be an actual hardworking organization, not an assemblage of dilettantes. Among its far-reaching activities, the council promoted military enlistments along with the sale of liberty bonds; helped raise money for the Red Cross and other charitable organizations; directed efficiencies in farm and fuel production, transportation and conservation; and established a bureau to help prevent fraudulent war relief schemes. Hopkins said he regarded his role as the most compelling obligation of his life. Insull described him as indefatigable. After the war, Governor Lowden hailed the council as "the premier body of its kind in the United States."

Roger Sullivan examines a gas mask in his role as member of the Illinois State Council of Defense. *DN-0070316*, Chicago Daily News *negatives collection, Chicago History Museum.*

Just as the Bible speaks of war and pestilence, the United States faced this double scourge as the conflict entered its final weeks. The great influenza epidemic of 1918 was raging. In Chicago, health officials predicted that by the end of winter, as many as one million could be affected. Army posts and navy stations with personnel living together in close quarters found

themselves particularly hard hit. In response, the Illinois Council of Defense created a commission of medical authorities to address the calamity, not only as it affected the troops but in all sectors of the state. The newly formed commission immediately recognized an alarming shortage of doctors, nurses and hospital beds. Three primary causes created the emergency: the sheer volume of rapidly multiplying cases, the unavailability of a substantial number of doctors and nurses serving in the military and a disproportionate toll among those medical people who remained.

By the end of the outbreak's first week in early October, forty to sixty thousand cases were estimated in Chicago alone. Military service had reduced medical staffs by as much as 40 percent. In many smaller towns, no doctors or nurses could be found. Those remaining in the city were falling ill themselves. Chicago's West Side Hospital reported twenty-five flu cases among the nursing staff, with three fatalities. At Michael Reese Hospital on the near South Side, a dozen cases were reported among the nurses.

Around October 1, John Hopkins developed a throat infection. He thought little of it and continued his work at the defense council. A week later, the city Health Department recorded 1,053 new flu cases within the previous twenty-four hours. Hopkins was one of them. His doctor ordered him to bed. Dapper Johnny considered the flu one more opponent to confront and conquer. He said as much to Roger, his sisters and other well-wishers who gathered at his bedside. On Saturday, October 16, all of them would have loved to be three miles north, straight down Michigan Avenue, where Liberty Day festivities were getting underway. At 1:00 p.m. sharp, a bugler signaled the step-off of a gigantic parade to again encourage the purchase of liberty bonds. Had circumstances been different, Johnny and Roger would have joined their old adversaries, U.S. senators Lawrence Y. Sherman and J. Hamilton Lewis, who fell in with other dignitaries and led a curb-to-curb procession on a serpentine route from Grant Park, at the foot of Van Buren Street, north on Michigan, through downtown, to Franklin and Randolph Streets. Police were forced to push back jostling throngs that scrambled to get a look at men riding high-stepping horses, five thousand blue-uniformed sailors from Great Lakes station, thousands of non-uniformed recent draftees, scores of marching bands, Boy Scout troops and a flag-waving contingent representing thirty-seven different nationalities. The war apathy once feared by Sam Insull was nowhere in sight. The council had outdone itself. Secretary Hopkins would have been proud.

The former mayor was chatting with Roger and family members about 5:40 p.m. the following day, perhaps going over newspaper descriptions of

the triumphal parade, when Hopkins's heart failed. Twenty minutes later, he was gone, sixteen days shy of his sixtieth birthday and less than a month before the guns in Europe fell silent. Dapper Johnny went out a hero. The newspapers, civic and government leaders unequivocally attributed his death to overwork on behalf of the defense council. "J.P. Hopkins' Death the Result of War Work," declared a *Daily News* headline. Hopkins "died… as a result of devotion to war work," the *Tribune* agreed. Governor Lowden said, "I fear his great devotion to the work of the State Council of Defense contributed to this end." Sam Insull averred his firm belief "that had it not been for his wholehearted and earnest devotion to the work of the council, he would be alive today." Collectively, those words carved the Hopkins epitaph: the man died in service to his country, just as if he had fallen in the Argonne Forest. No one mentioned Ogden Gas.

Some believed that John Hopkins was never the same after the death of his mother. One friend attending the ex-mayor's funeral said Hopkins once told him that after her passing, he and his sisters frequently went to church because it was the only place where they could find consolation. Roger Sullivan's innermost feelings could only be imagined. His public words have become a cliché among politicians mourning the loss of another. Richard J. Daley uttered them many times. "Chicago has lost a valuable citizen, and I have lost a dear friend." The task of providing more incisive eloquence was performed by a *Daily News* reporter named Frank Armstrong. "The love of man for man that existed between Mr. Sullivan and Mr. Hopkins was the kind that endures beyond the grave."

As executor of the Hopkins estate, Sullivan was required to file a report with probate court, where as clerk he'd held his only elected office. To no one's surprise, the report showed that Johnny had done very well for himself. Total value of the estate was estimated at $7 million, depending on the vagaries of the stock market, or well over $100 million by measurements a century later. A substantial portion of Hopkins's wealth rested with companies controlled by his onetime foil and later friend Sam Insull. The largest chunk of the estate, 12,253 shares of Commonwealth Edison stock, held a value between $1.2 million and $1.4 million. Hopkins also owned stock valued at $500,000 in Public Service Company of Illinois, $219,000 in Middle West Utilities and $150,000 in Northern Utilities Company—all Insull properties.

Speaking of former foils, Hopkins retained shares of Peoples Gas with a market value of $204,000. He maintained substantial investments in three companies on whose boards he served—Great Lakes Dock and Dredge Company, $728,000; Consumers Company, $104,000; and Chicago

Pneumatic Tool Company, $56,000. Union Carbide and Carbon represented his largest holding after Commonwealth Edison—$960,000. He kept cash in three banks totaling $191,000 and, faithful to his final calling, held $100,000 worth of liberty bonds.

Presumably for sentimental reasons, Hopkins kept a $1,000 note of the Arcade Trading Company, the firm he established with Fred Secord, and held $40,000 in Pullman Company stock. Maybe he retained those shares for sentimental purposes, too. In any case, after everything was tabulated, it was clear that his sisters would be well cared for.

During the 1919 mayoral campaign, which featured a rematch between Mayor Thompson and Roger's candidate, Bob Sweitzer, Sullivan made one of his increasingly frequent trips to Florida. In Palm Beach, he received word that his daughter Helen (Mrs. William P. McEvoy) had died of heart failure at age thirty. She had been under a doctor's care for two weeks, but her father apparently didn't consider the situation serious enough to postpone his getaway. He rushed home to join the family and make funeral arrangements. First Johnny, now Helen, within five months.

Personal losses, especially those experienced later in life, have a way of making an individual take a fresh look at relationships with family, friends, rivals—even enemies—and in the case of Roger Sullivan, a faithful Catholic, the Almighty. Possibly sensing his own mortality as he entered what would become the final year of his life, Sullivan chose to forgive and forget. He turned his attention to the presidential election year of 1920, trying to put political setbacks of the two previous years behind him. During the first week of the new year, he and a delegation of Democrats headed to Washington to make a pitch to the national committee for the selection of Chicago as host city for the nominating convention in late June. The Republicans already had chosen Chicago for their conclave.

The Illinois juggernaut, competing against San Francisco and Kansas City, made the first presentation. The group's entrance into the Shoreham Hotel ballroom triggered an uproar. Leading the delegation, linked arm-in-arm, were those seemingly eternal archenemies Roger Sullivan and Carter Harrison. The former mayor spoke first, admitting the obvious, that he and Roger had had their differences. "But we are here now, together, to plead a common cause, harmoniously, under a common roof." Sullivan, as usual, spoke more prosaically, but neither approach mattered; San Francisco had the prize in the bag from the start. Chicago finished a distant third, behind Kansas City, whose spokesman, 1912 presidential contender Champ Clark, put his best face on the proceedings. "The statement that Mayor Harrison,

Senator [J. Hamilton] Lewis and Roger Sullivan are working together is about the most exciting thing I have ever heard. If they can work together in harness, surely the rest of us can." The Democrats understood they would need all the teamwork they could muster because 1920 was shaping up as a Republican year, possibly of seismic proportions.

Champ Clark would have found himself even more encouraged, if not altogether astonished, had he ridden the train back west from Washington with Roger and his traveling companion. Who would have dreamed that the Chicago boss and William Jennings Bryan, who had famously denounced him as a "train robber," would be enjoying each other's company aboard a train, passing much of the time in the same compartment?

In the winter and spring of 1919–20, Sullivan was forced to deal with matters more pressing than the fall elections; his health was failing. He had divided the winter between Palm Beach and Hot Springs, Virginia, interrupting the stays to attend the January national committee meeting in Washington. In late March, he developed a bad cold that affected his bronchial tubes and left him unable to speak at times. He had been taking heart medication for years. At the end of the month, his condition worsened. The two doctors treating him at his Wellington Avenue residence became alarmed by his temperature, pulse and abnormal respiration. Pneumonia set in. The doctors were able to stabilize the worrisome signs and prevent a threatened abscess in one of the lungs. They pronounced him out of immediate danger, and the patient spent the next day resting comfortably. His physicians considered his general condition sound and his heart satisfactory for a man of fifty-nine with a history of cardiac trouble. They believed that heart complications notwithstanding, he would recover. The patient believed so as well. He discussed the primary election results with aides and expressed hope of attending the June convention in San Francisco. But by midafternoon on April 14, Sullivan began to sink fast. Helen summoned the doctors, the children and the parish priest. When the first doctor arrived about half an hour later, he told the family that little hope existed. They propped him up in bed and placed pillows behind him. Helen asked whether he felt any easier. He replied, "No, I am not any easier." Those were his last words before falling into unconsciousness.

Accolades and words of sympathy in the form of telegrams inundated the Sullivan household. President Wilson, or someone writing in his behalf, wired Helen, "You have my deepest sympathy. I shall never forget what a good friend your husband was to me." Additional messages arrived from Governor Lowden, Carter Harrison, Archbishop George Mundelein and

politicians of both parties. Mayor Thompson established a new standard for insensitivity. After expressing his sorrow and calling Roger a fine man, Big Bill, per usual, couldn't keep his large foot out of his larger mouth. "I saw him about a month ago. He looked bad then, and I'm not surprised to hear he is dead." The mayor then departed on a scheduled vacation to Florida, leaving his secretary to convey his regrets to the family.

That many felt the loss became obvious by the huge crowds that gathered to say goodbye. Before the funeral ceremonies began, the body lay in state at the Sullivan home, surrounded by hundreds of floral tributes. A stream of mourners figuratively seemed to stretch to city hall and beyond. Bank presidents, political leaders and everyday folk passed through the room. The cortege traveled from the residence to Holy Name Cathedral, some three miles south. Total estimates of those who rode in hundreds of cars or made the walk fell between seven to eight thousand, more than double the number who turned out to bid farewell to the other half of the legendary Hopkins-Sullivan combine. From Holy Name, the journey continued for about fifteen miles west, to Mount Carmel Cemetery in Hillside, where Roger was laid to rest beneath a giant cross remarkably similar to Dapper Johnny's, an entire city and swath of suburbia away in Calvary.

Roger Sullivan left an estate conservatively estimated at $10 million, worth ten to fifteen times that much nearly a century later. Stocks and bonds represented much of his wealth. His Sawyer Biscuit Company was valued at approximately $4 million, and he maintained large holdings in Great Lakes Dock and Dredge Company, which he also managed for a time. The Peoples Gas acquisition of Ogden Gas added further to his wealth, but unlike Hopkins, he didn't retain a stake in the surviving gas company.

Soon after his father's death, Roger's son, Boetius, a successful attorney, announced the creation of a charitable and educational fund to perpetuate the deceased's memory. Each year, top students in Chicago's public and parochial high schools would compete for a Roger C. Sullivan Scholarship. The winner could attend any college—provided it wasn't "socialistic" or "atheistic"—and receive tuition, room and board for four years. Boetius had already created four scholarships at his alma mater, Andover Academy. One was named in memory of John P. Hopkins.

In the mid-1920s, the City of Chicago built a high school on the far North Side and named it in honor of Roger Sullivan. The school opened in 1926, but the city didn't get around to dedicating it until two years later. The ubiquitous Sam Insull served as principal speaker. A bronze tablet, the work of a sculptor commissioned by the family, was presented to the school.

The honor didn't set well with at least one individual. In one of his patented scribblings—to himself, to posterity, one is left to wonder—Carter Harrison groused about the inequity of naming a school after someone of Roger Sullivan's ilk. The very idea of the man as a role model for high school students. The city did name a high school for Carter Harrison, an imposing gray edifice on the near Southwest Side. But the building was dedicated to the memory of Carter I, not the son. From beyond the grave, Roger had one-upped his most persistent antagonist, who had more than another quarter century to scribble notes in his diary and consider the unfairness of it all. Carter Harrison II died Christmas Day 1953 at age ninety-three.

And what of Billy Lorimer? Following his expulsion from the Senate, Lorimer revolved in and out of Illinois politics for the next twenty years. The election of his protégé, Big Bill Thompson, as mayor in 1915 brought few benefits to the Blond Boss. He saw himself supplanted by others in the Thompson inner circle. The next year, Lorimer tried but failed to win a congressional nomination. He spent the following ten years making wise investments and accumulating a reported $100,000 to repay his former bank depositors, according to Professor Tarr.

By 1927, Lorimer was back in Thompson's good graces and running the election campaign that returned Big Bill to the mayor's office after an absence of four years. Billy turned his attention to state politics in the early 1930s and campaigned across Illinois for the re-nomination of Governor Len Small. Physical problems followed. Heart trouble plagued him for the better part of a year and a half, and on September 3, 1934, he died of a heart attack at the Chicago and North Western rail station upon returning from a family outing. He was seventy-three.

Like John Hopkins and Roger Sullivan, William Lorimer made many friends during a checkered career. A throng gathered at St. Catherine of Siena Church in west suburban Oak Park to say farewell. They talked of how the Blond Boss never forgot a friend. Surely someone recounted his final meeting with Sam Insull five months earlier. The utilities kingpin had just been returned to the United States by federal authorities to stand trial on mail fraud charges. Insull had fled to Europe after his empire collapsed and caused thousands to lose their life savings. Lorimer and his family were among the unfortunate. Nonetheless, there was Billy, waiting to greet Insull, broken in health and spirit as well as finances. Lorimer handed the old man an envelope containing $500.

William Lorimer never forgot a friend.

BIBLIOGRAPHY

Adelman, William. *Touring Pullman*. Chicago: Illinois Labor History Society, 1972.

Altman, Linda Jacobs. *The Pullman Strike of 1894: Turning Point for American Labor*. Brookfield, CT: Millbrook Press, 1994.

Blue Book of Cook County Democracy. Chicago: P.F. Pettibone, 1902.

The Book of Chicagoans. Chicago: A.N. Marquis, 1905, 1911.

Boone County Illinois, History. Chicago: Boone County History Museum, n.d.

Bright, John. *Hizzoner Big Bill Thompson*. New York: J. Cape and H. Smith, 1930.

Buder, Stanley. *Pullman: An Experiment in Industrial Order and Community Planning*. New York: Oxford University Press, 1967.

Bukowski, Douglas. *Big Bill Thompson, Chicago and the Politics of Image*. Urbana: University of Illinois Press, 1998.

Chicago City Council, Regular Meeting, February 25, 1895, Official Meeting transcript.

Dedmon, Emmett. *Fabulous Chicago*. New York: Atheneum, 1953.

Doty, Mrs. Duane. *The Town of Pullman*. Chicago: Chicago Pullman Civic Organization, 1974.

Dunne, Edward F. *Illinois, the Heart of the Nation*. Chicago: Lewis Publishing, 1933.

Green, Paul M., and Melvin G. Holli. *The Mayors*. Carbondale: Southern Illinois University Press, 1987.

Ferrell, Robert H. *Wilson*. New York: Harper & Row, 1985.

Harrison, Carter II. Personal Papers, Newberry Library, Chicago.

———. *Stormy Years*. Indianapolis, IN: Bobbs-Merrill, 1935.

Hopkins Family Burial Records, 1912–2005, Calvary Cemetery, Evanston, Illinois.

Howard, Robert P. *Mostly Good and Competent Men*. Springfield, IL: Sangamon State University and Illinois State Historical Society, 1988.

Hutchinson, William T. *Lowden of Illinois: The Life of Frank O. Lowden*. Chicago: University of Chicago Press, 1957.

Ida Public Library, Belvidere, Illinois, McKinley/Sullivan and Related Families, 1999–2004, and Sullivan Family History, n.d.

Insull, Samuel. *The Memoirs of Samuel Insull*. Polo, IL: Transportation Trails, 1992.

Kogan, Herman, and Lloyd Wendt. *Lords of the Levee*. Evanston, IL: Northwestern University Press, 1943.

———. *Lusty Bosses of Chicago*. Bloomington: Indiana University Press, 1943.

Lindsey, Almont. *The Pullman Strike*. Chicago: University of Chicago Press, 1942.

McDonald, Forrest. *Insull*. Chicago: University of Chicago Press, 1962.

Platt, Harold L. *The Electric City*. Chicago: University of Chicago Press, 1991.

Pullman Company Files, Secretary's Office 1887–1897, Newberry Library, Chicago.

Smith, Carl S. *Urban Disorder and the Shape of Belief*. Chicago: University of Chicago Press, 2008.

Stead, William T. *If Christ Came to Chicago*. Chicago: Chicago Historical Bookworks, 1894.

Sutter, R. Craig, and Edward M. Burke. *Inside the Wigwam: Chicago Presidential Conventions 1860–1996*. Chicago: Loyola University Press, 1996.

Tarr, Joel Arthur. *A Study in Boss Politics: William Lorimer of Chicago*. Urbana: University of Illinois Press, 1971.

Tierney, Kevin. *Darrow, A Biography*. New York: Crowell, 1979.

United States Strike Commission Report on the Chicago Strike of June–July 1894, 1894. Washington, D.C.: U.S. Government Printing Office, 1894.

Wasik, John. *The Merchant of Power*. New York: Palgrave MacMillan, 2006.

Weimann, Jeanne Madeline. *The Fair Women*. Chicago: Academy Chicago, 1981.

Weinberg, Arthur and Lila. *Clarence Darrow, A Sentimental Rebel*. New York: Putman, 1980.

Wendt, Lloyd. *Big Bill of Chicago*. Evanston, IL: Northwestern University Press, 1953.

INDEX

W

Y

ABOUT THE AUTHOR

Chicago native John F. Hogan is a published historian and former broadcast journalist and on-air reporter (WGN-TV/Radio) who has written and produced newscasts and documentaries specializing in politics, government, the courts and the environment. As WGN-TV's environmental editor, he became the first recipient of the U.S. Environmental Protection Agency's Environmental Quality Award. His work also has been honored by the Associated Press. Hogan left broadcasting to become director of media relations and employee communications for Commonwealth Edison Company, one of the nation's largest electric utilities. Hogan is the author of Edison's one-hundred-year history, *A Spirit Capable*, as well as four other Chicago books with The History Press: *Fire Strikes the Chicago Stock Yards*, *Forgotten Fires of Chicago*, *The 1937 Chicago Steel Strike* and *The Great Chicago Beer Riot*. He holds a BS in journalism/communications from the University of Illinois at Urbana–Champaign and presently works as a freelance writer and public relations consultant.

Visit us at
www.historypress.net